MW00804019

# Flourish

## PROJECTS, TECHNIQUES AND CREATIVE NUDGINGS
### FOR
## POLYMER CLAY AND MIXED MEDIA

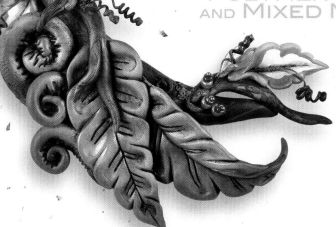

## BOOK ONE

# Flora

*leaf, flower & plant designs*

## CHRISTI FRIESEN

I'm not the first to liken creativity to a journey, but I've added graphics!

In this book, I'll be your companion for the journey. Sometimes a guide, sometimes a fellow tourist, and sometimes that-weirdo-in-the-group-that-keeps-asking-questions-when-everyone-else-just-wants-to-go-to-the-cafe-for-an-espresso.

## outfitting yourself for your Creative Journey

**rose-colored glasses:** for seeing the interesting creative possibilities

**wallet:** you don't have to spend money on supplies, but you probably will. check out the back of the book for some suggestions on what kind o' stuff you can't live without

**padding:** you'll probably be sitting a lot when you clayplay, something cushy to sit on is always a good idea!

**animal fur** if you have a pet, this will get into all your projects. good luck with that

**clicking finger:** for internet browsing. there's a lot of cool stuff online to make your journey even more exciting! oh, where would we be without the internet?! sure, we'd have more time in our lives to get things done, but would it really be living?

**art supplies** clay and other fun stuff (look in the back of the book for more details)

**strong elbows:** to sweep everyone out of your space so you have room to work

**positive attitude:** go get some sunshine on your face if you can - it really helps you feel ready to create. if you live in one of those grey places, take two vitamin D pills and call me in the morning.

**shoes:** optional

## Destination: FLORA

Here's the deal about creativity - you can be artistic without it. You can have great technical skills, you can have the ability to masterfully use your medium (which in this book will be polymer clay), but if you lack creativity, your work won't snap, crackle or pop.

You can imitate the creativity of others (which is a great way to learn), and be propelled forward by their imaginations (that's what this book is all about), but ideally, your creative journey should take you to a place where your own ideas bloom and flourish. Ready? Let's wander....

# SUPPLIES FOR YOUR CREATIVE JOURNEY
### keep these on hand

books for inspiration and reference

How to Spend All Your Money on Craft Supplies

THE BESTEST POLYMER ART IN THE UNIVERSE

Gimme Some Chocolate

Professor Contraption's Guide to Steampunkery

So Many Pretty Things

**chocolates** - a must have to keep your imagination juices flowing. oh, it's true. chocolates strengthen creativity. and if it's not true, I still chose to believe it.

**your inner child** - don't lose this

**Interesting things –** clutter your world with stuff whose colors, textures, shapes and patterns inspire you.

**brain -** I always keep a spare around in case the one I'm using gets a little sluggish.

**camera/phone/iPad -** for instantaneously snapping those shots of clever, interesting and inspiring things. you don't have to be a great photographer, you just have to be good at seeing what's worth photographing.

**sketching stuff -** doodles are good. record your inspirational thoughts, visualize possibilities by scribbling them when the ideas hit you.

to add connectors

to add dangles!

PRISM+

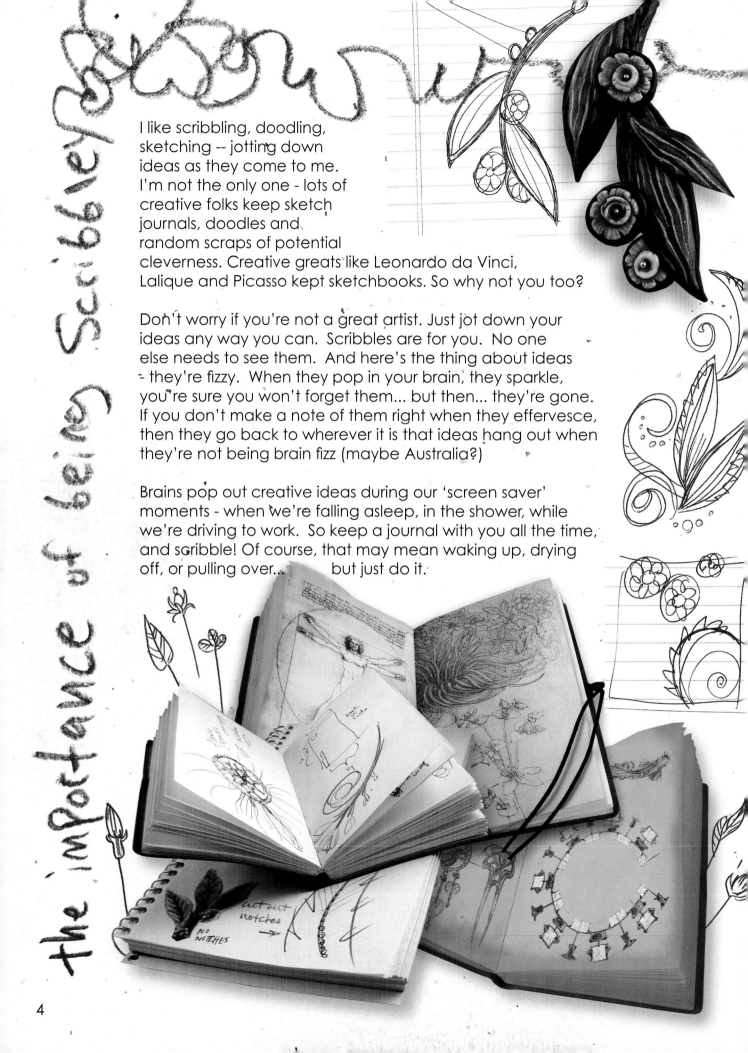

I like scribbling, doodling, sketching -- jotting down ideas as they come to me. I'm not the only one - lots of creative folks keep sketch journals, doodles and random scraps of potential cleverness. Creative greats like Leonardo da Vinci, Lalique and Picasso kept sketchbooks. So why not you too?

Don't worry if you're not a great artist. Just jot down your ideas any way you can. Scribbles are for you. No one else needs to see them. And here's the thing about ideas - they're fizzy. When they pop in your brain, they sparkle, you're sure you won't forget them... but then... they're gone. If you don't make a note of them right when they effervesce, then they go back to wherever it is that ideas hang out when they're not being brain fizz (maybe Australia?)

Brains pop out creative ideas during our 'screen saver' moments - when we're falling asleep, in the shower, while we're driving to work. So keep a journal with you all the time, and scribble! Of course, that may mean waking up, drying off, or pulling over...        but just do it.

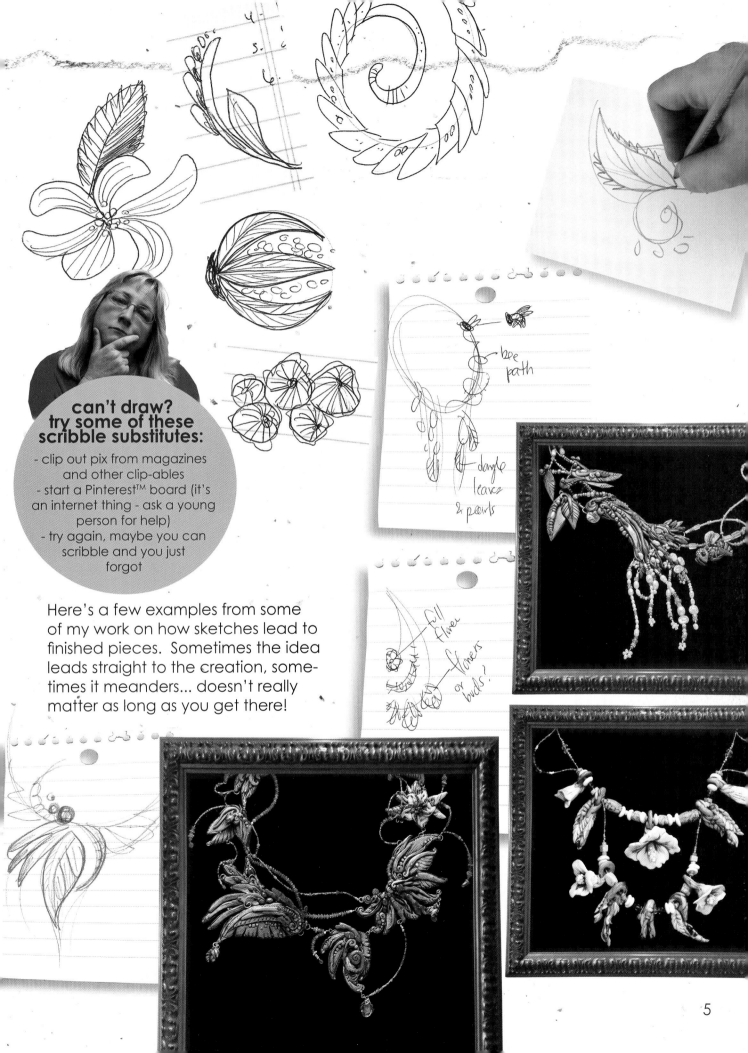

Here's a few examples from some
of my work on how sketches lead to
finished pieces. Sometimes the idea
leads straight to the creation, some-
times it meanders... doesn't really
matter as long as you get there!

bee
path

dangle
leaves
& pearls

full
flower

flowers
or
buds?

# Tools & other needful things

All the projects in this book will use polymer clay as the primary art medium. We'll use tools to manipulate and transform the clay, powders and glitters and paints to add additional colors, and beads, wires and other fun things to add interest and excitement! As we go along, we'll discuss all these things, but I suggest that you take amount right now to look at the materials in the "Back O' the Book" (the official section for additional information... located in the back of the book, obviously).

Polymer clay needs to be conditioned before being used, baked to harden, and stored when not being used. You'll find info about that in the Back O' the Book! And what about mixing special clay colors? adding beads? making and using molds? You'll be introduced to those things as we go along, with the detailed information in the BOTB.

So, when in doubt, peek in the back.

There are also some really helpful resources about where to find the items I've used in all these projects.

So, skip to the end, and then I'll meet you back on page 7!

All polymer clay is awesome. My preference is Premo™ brand clay. It's a great sculpting clay. So, just assume references in this book to clay are talking about Premo.

# 'Flora'

## a not-so-typical specimen

### 1. blooming & fruity parts

This is what it's all about for most flora - the showy parts, the pizzazz, the glamour! We artist-types like this part the most too, it's where the color is - flowers and fruits and buds and pods and berries. Yes please!

### 2. stem & branchy bits

This part is necessary or you'd have leaves and flowers laying all over the ground. Look for unexpected design and composition possibilities within the realms of branches, stems, tendrils and vines. This is also a great place for artistic embellishments in the form of beads, chain, and other strands of interesting stuff.

### 3. leafy things

Color and excitement are alive and well in the leaf department! Artistically, leaves yield a bountiful playground of ideas - you can curve them, drape them, group them, stylize them! Leaves are usually the main component of design. Get them right, and the piece works.

### 4. the unexpected stuff

In the world of flora, there's unexpected stuff to lure you into creative possibilities - texture in the bark of a tree, whorls of pattern in the needles of a cactus, the fuzzy weirdness of moss. This is also where you'll find opportunities to get out your stash of mixed media accents and embellishments to enliven your creations.

### 5. roots and grabby parts

Something's got to hold a plant firmly to its environment, and roots volunteered to do the job. Roots are straightforward, but that doesn't mean that they're dull or that they don't have some interesting artistic possibilities.

### did you know?

"Flora" was the Roman goddess of flowers and plants, so it makes sense that we'd use her name to refer to all plant life. I'm just glad it's so easy to spell!

# Making leaves is fun. Really, really fun.

I thought it would be a good idea to race through the steps on making a few leaves as the first thing we do. You'll use leaves in lots of the projects and ideas in this book. These are stylized leaves. That means we're not going for realism, we're going for artsy.

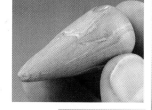
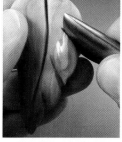

**My Favorite Leaf**
This really is my favorite leaf. I use it all the time!
You can use it too, if you want to.

Make a ball of clay and form it into a teardrop (remember there are some more details in the back of the book if I mention something you're not familiar with. I assume you can make a ball, but if teardrops are a problem, I've got a trick for that. Honest. Check the back of the book if you don't believe me!) Flatten the teardrop with your fingers so that it's about as thick as a dollar coin (or a one euro coin if that's what's in your pocket). Fingerprints are good. We like them on the clay.

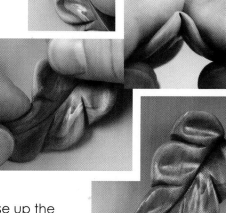

Use a needle tool to impress a deep line down the center of the clay.

Use a tool (I suggest the GHI tool – look in the back of the book!) to press notches into the edges of the clay. If you press the notch into the side, then roll the tool onto the surface of the clay all in one motion, you'll create the veins too. Sweet. Notch/vein both sides of the leaf so that the lines are angled towards the round end.

Use a tool (the other end of the GHI works great) to press an indentation into each section.

Press the leaf along centerline, by pinching on the backside. This will close up the centerline, which looks nicer, and it will give the leaf a valley in the middle, much prettier than it just laying there all flat and bored.

And speaking of boring – add some curves to your leaves. A twist, a curl, a little lift! These finishing touches make the clay come alive.

Finally, if you want to, you can use mica powders to add color and shimmer to your leaves. It really glams up a leaf! (Back o' the book for details, if you're intrigued....)

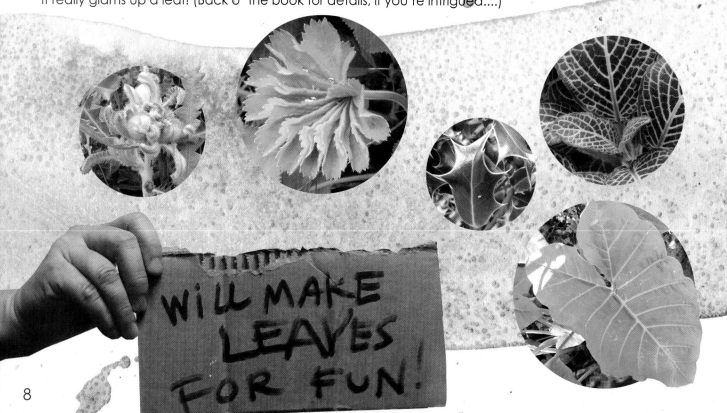

### Road Kill Leaf

Well, it's not really road kill, of course, but as we make it, it'll look at first like it was run over by a truck, so....

Roll out a ball, make a teardrop, flatten it. So far, nothing new. Use the needle tool to press a line down the center of the leaf. Add more lines, parallel to the middle line until the whole leaf looks like a truck ran over it.

Pick it up, and pinch the FAT end together, like a taco. Roll that pinch between your fingers – now it's a taquito! (which is a rolled-up taco, in case you were wondering).

Tweak the tip of the leaf so that it curves, ever so daintily. Add a bit of mica powder to the inside – something deep like blue or brown.

These leaves look especially nice in clusters of three or more.

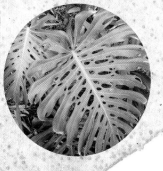

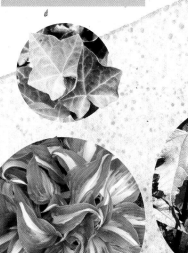

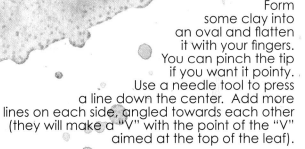

### The Generic Leaf

I call it this because it's exactly what we think of when we think of a leaf. Long, pointy at the tip with a centerline and veins. It's as easy to make as it is to describe.

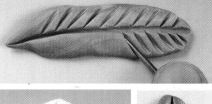

Form some clay into an oval and flatten it with your fingers. You can pinch the tip if you want it pointy. Use a needle tool to press a line down the center. Add more lines on each side, angled towards each other (they will make a "V" with the point of the "V" aimed at the top of the leaf).

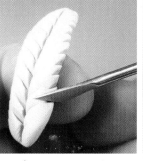

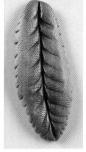

For funsies, you can use a sharp tool (I recommend the CLWI tool) to press little notches along the sides for a serrated leaf variation.

Powder down the centerline for maximum awesomeness.

## A Forest Leaf

This leaf is the kind that's found on most of the forest-type trees. This style leaf can be varied in so many ways (you'll have to play around with that later).

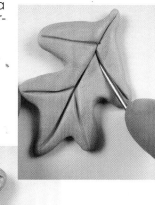

Start with a flattened teardrop. Use a needle tool to draw a shallow center-line and several vein lines branching off. Use a tool (GHI again) to press notahes BETWEEN the lines.

Use your fingers and tools to smooth and shape those leaf lumps (you can call them lobes if you're feeling all scientificy).

Go back with your needle tool and make the vein lines more pronounced. Add additional lines coming off each main vein.

Here's a fun mica powder trick that looks especially good with this type leaf. Brush mica into all the lines. Press a piece of clear tape onto the surface of the leaf and rub gently. Pull it off, and the excess powder along with it! You'll need to use several pieces of tape to get all the surface mica off, leaving color in the lines. Nifty, huh?

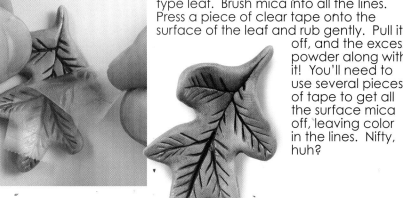

## Mr. Fancy Leaf

Make a little eye shaped piece of clay – like a teardrop with both ends pointy. Flatten it. Make two more, smaller and flatten them too. Press all three together, big one in the middle. Aw, let's add two more smaller ones at the top.

Use a tool (this time it's the WIA tool) to smooth all the clays together on the backside. Flip it over.

Roll a thin snake from a contrasting color clay and lay it on top of the leaf, right down the center. Add more veins down the center of each leaf section.

Use a tool to pull lines from the edge of the vein clay, over the top of the leaf section all the way to the edges.

A bit of dark powder where the side stems meet the main stem looks great.

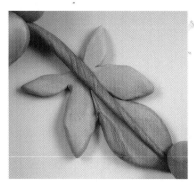

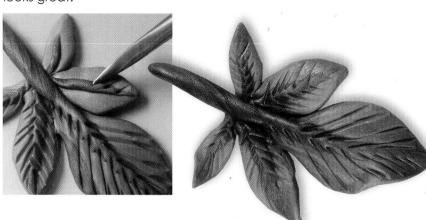

## Holey-er Than Thou Leaf

This is a great jungle leaf, and usually steals the show when used in a design. Start with a sheet of clay, rolled out on the thickest setting of your clay-conditioning machine. (about as thick as a quarter coin) Use a needle tool to draw the leaf pattern, and the center line. I think a squashed-heart shape is best.

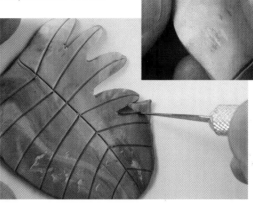

Use your fingers to soften the edges and take away the "cookie-cutter" edge.

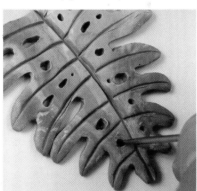

Use a needle tool to draw lines from the center out to the edges. These will be the centerlines of each leaf lobe. Use a craft knife to cut a curved piece from IN BETWEEN each of those lines. This makes the wiggly leaf edge!

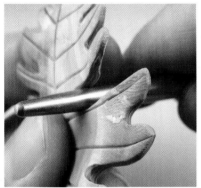

Use fingers and tools to smooth the edges and the curvy parts.

Make holes in the fleshy part with a needle tool. Just poke it in and wiggle it.

Pinch the centerline from the backside to bring the leaf together. Powder down the center to make it sizzle!

Ooooooooooooh, so many leaves to explore!

### Imperfections

If you want an arrangement of leaves in a piece to look more realistic, add a flawed leaf. First make the leaf correctly, then use a tool to rip off some of the clay to mimic an old, damaged or insect-attacked leaf. A touch of brown powder in the rough area will enhance the effect.

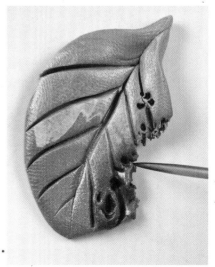

# a word about caning

"Caning" refers to a technique whereby clay is pieced together so that the pattern is revealed when the clay is cut open. It is an ancient glass-making technique, which polymer artists have enthusiastically adapted. Caning tricks and patterns are as numerous as the artists who create them, so if caning appeals to you, you'll want to do a bit more exploring on your own to see all the ideas out there! Check out the Back o' the Book section (it's in the back of the book, duh) for more caning information and resources.

I like to make micro-canes.
Little bits of caning patterns that only yield a few slices. They make great leaves.

This cane is a simple concept with endless possibilities. Start out with a small stack of layers of contrasting green clays. You can make the layers thin with your fingers, a roller or a clay-conditioning machine... or a sledge hammer, if you have anger issues.

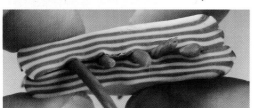

Cut the stack in half and lay thin, colorful snakes of clay on one half. Cover them with the other half stack. Press together in between each snake so that there is clay between each, not air (it looks better). This is a trick I learned from master caner, Sarah Shriver. She likes to put things inside her canes. I love that, so I asked her if I could too, and if I could tell you also, she was cool with it.

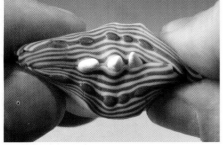

If you want to, you can cut that stack in half and add more snakes of a different color, and press them all together.

Once you've made as many stacks as you want, press the whole thing into a leaf shape by squeezing the ends into a point and squishing the ends towards the middle to fatten it up a bit. You can also make the leaf smaller by pulling and squeezing so that the whole thing gets longer and smaller (this is a cane reducing technique).

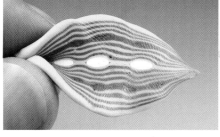

Once you've got it to the shape and size you like, use a sharp, thin blade to cut off a slice about as thin as a ten cent coin. Manipulate that into a finished leaf (I like to pinch one end into a taco/burrito kinda' thing). Tah dah!

You're a caner.

Some of the fun you can have with canes.

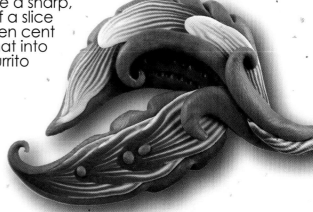

12

Ready for another micro-cane? I call this one the WiggleScribble cane, for what will become obvious reasons. It's a chaos cane and the more sloppy you are, the better it works. It's best to use scrap clay, so just gather up the bits on your work space – make sure there is lots of contrast, lights and darks and colors!

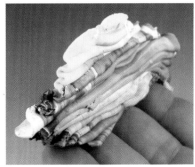

Press the clays together to make a wad about the size of a walnut. Smash that wad flat (use a roller). Rip the sheet of clay and stack it. Do that again. Stop! No more ripping and stacking. Flatten the stack with your hands or with a roller.

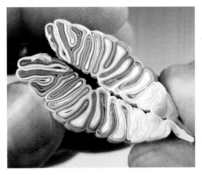
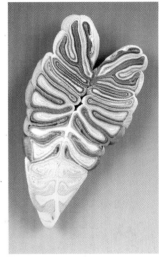

Set your clay-conditioning machine to one notch thinner than the halfway setting. Roll the clay stack into the machine, BUT make sure your fingertips are pressed right under the machine so they're touching the rollers. As the clay comes through, it will get stopped by your fingers and fold back and forth into a pleat. You can move your fingers a little to accomodate the clay, but keep the pleat compact.

Cut the clump in half with your sharp blade and press the two halves together like a mirror image. Whatcha' think? Awesome, right?

Cut a slice, press and form it into a leaf shape. Cut more. Make something with them.

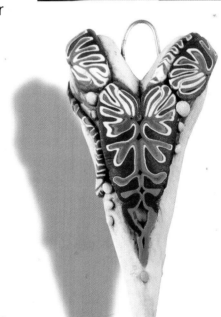

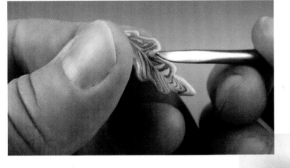

You can tweak canes too. Use a tool to press indentations in the side for a notched leaf. Or cut slices of cane to lay on the surface of other leaves. Experiment! That's how you figure out new things.

Polymer clay excels at providing the artist with a way to play with lines and colors. Play!

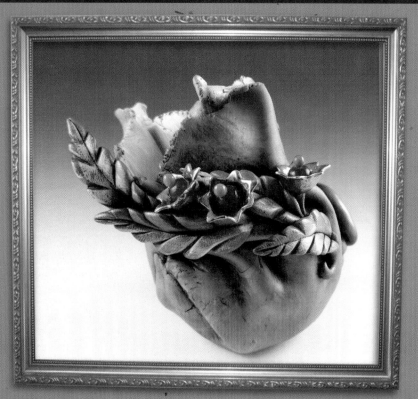

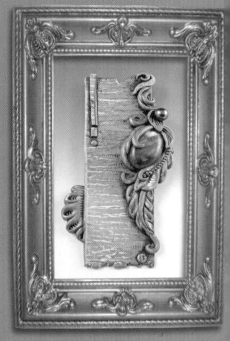

Leaves don't have to be realistic colors. Creating these leaves from gold and silver clay create a different, more decorative look. The added vein of clay and one of tiny pearls looks fancy, don't you think?

You'll recognize these leaves, they're just longer versions of "My Favorite Leaf" without the indentations in each lobe. Laid one on top of another to emphasize length gives this piece lots of movement.

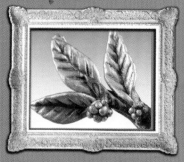

Super simple "Generic" leaves coated with a metal coating and aged (more about that later... spoiler alert!)

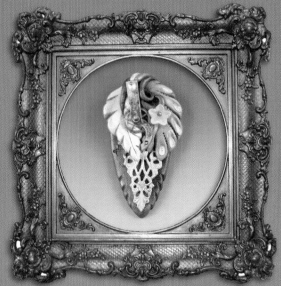

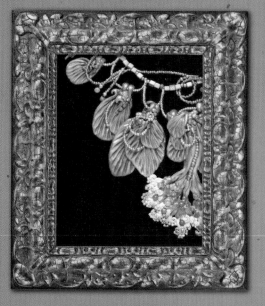

Get a little yin-yang thing going with contrasting colors of leaves. Oh, and if you add a teensy bit of clay in each leafy section, you can press it flat and drag it with a tool to add a fun bit of color. Neat, right?

Simple leaves can be stunning when you use good colors and group them together with interesting accents. These are just the "Road Kill" leaves, left flat. The clay was a combination of green and blue, which makes them more dramatic. The beads loop and drape to echo the curves of the leaves. Oh, and the whole thing wiggles really nicely when it's worn. Bonus!

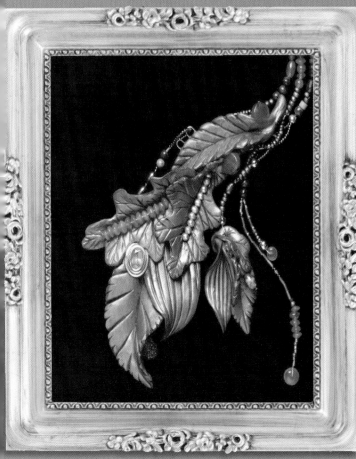

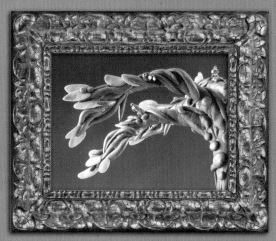

Never underestimate the power of simplicity. These leaves are just tiny balls of clay, formed into ovals and smooshed between fingers.

This cluster uses many of the leaf styles, but the coloring is what really makes it fun, I think. Also, that really yummy carnelian and sterling piece shows just how important the right accent can be to the overall beauty of a piece. There's some chitchat about adding things like this to your clay in the back of the book, if you're curious.

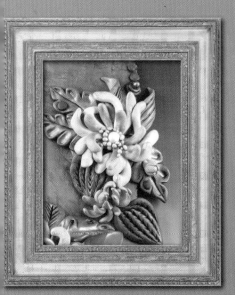

The right leaf, in the right place. Magic.

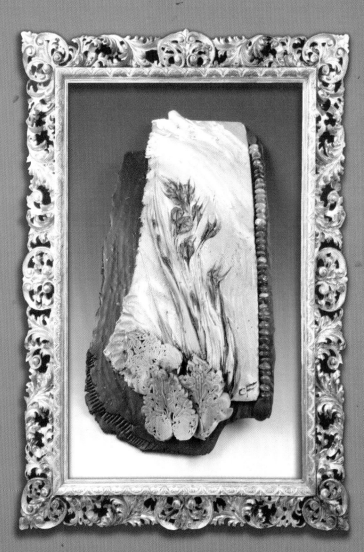

Oooh! Flowers! We'll get to those soon, but for now look at that one leaf at the lower right corner. It's just that "Road Kill" leaf again, with a a few more lines pressed in for fun.

Those big lacey leaves at the bottom are the "WiggleyScribbley" cane technique with the airy holes left un-compressed. Yummy.

# round leaves

A few plants have round leaves. Nasturtiums have simple, almost perfectly round leaves. Geraniums are roundish, with lots of frilly edges.

You can experiment with your own round leaves, but here's a quick one that you may have fun with. Let's make a few round, wavy leaves- and cluster them on top of a metal box as a decoration. (You can put the leaves on any type of box lid, I just happened to have a silver one lying around).

Start with a ball of green clay and flatten it with your fingers. Use a tool to press indentations all around the edges, like dimples.

Use your fingers to press gently into all the dimples, softening them.

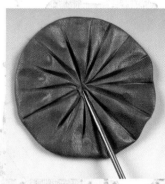

With your needle tool, draw lines, like spokes of a wheel, coming out from the center towards the edge.

Pick the leaf up, press a blunt-ended tool in the center, and gently crumple the leaf around the tool. This will make the circle look like a swirled skirt. You can pinch the center backside a little to help hold the new shape.

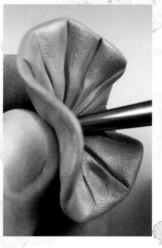

Make two more leaves! (or more if you want to, but I had a small box and only three leaves will fit on it).

It's good to have a base of clay for the leaves to connect onto easily. You can just roll out a ball of clay and flatten it, but if the clay has a texture on it, it will look more finished.

One easy way to add a texture is to press a pancake of clay onto a textured mold or stamp. I have a nifty mold of a cactus skeleton – it's awesome! so I used that. (If you want one too, check out Resources in the back of the book. If you want to make your own texture mold, it's super easy – go to the Back Of The Book for that info also!)

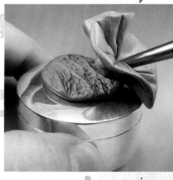

Press the textured clay onto the box. Use that blunt tool again to press the leaves onto the clay.

Of course mica powder will make the piece look luminous. A dusting of gold along the leaf edges and misty purple in the center looks really nice.

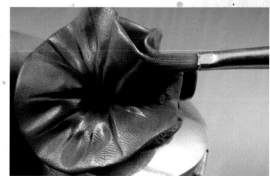

Adding a flourish of beaded spikes looks great with this type of leaf. Accomplish this by taking a headpin, stacking it with beads, then bending the end into a hook. (Look in the back of the book for a more thorough how-to.)

Push the beaded pins into the center of the leaves.
Try adding a few ball-tipped head pins without beads too.

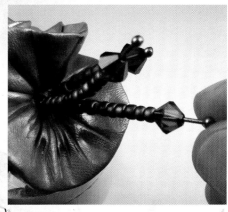

One word about baking. Many boxes don't really like going into the oven for as long as it will take to bake the clay (the box I used is silver-plated and definitely doesn't like the heat), so do mold the clay onto the box to get the angles and proportion correct, but then gently pry the clay off the box and set it onto a little nest of toilet paper or paper towels to bake (that will preserve the shape of the arrangement instead of the clay flattening out on a tile or baking pan).

After you bake your leaves (about 45 minutes for this one), you can use glue to re-secure it onto its box!

Unsure about which glues to use when? Head for the Back o' the Book where all will be revealed!

# water lily

And since we're talking about round leaves, let's talk water lily leaves! They're round, and interesting! So are water lily flowers and buds and pods (round, and interesting, that is). So, let's make them all - leaves, and buds and flowers and pods! They all go so well together (and just happen to make a great necklace project, too). Yeah, I know... this is the leaf section; buds and flowers and pods are later in the book. But hey! we can jump around if we want to! The sections of this book are all arbitrary anyway.

Each part of the water lily plant will make wonderful round, flat beads. Since round, flat leafs sometimes flipflop around when they are strung, I think it's a good idea if we create two channels (stringing holes) in each bead. Don't you agree? If you do, follow along... if not, well, I can't see what you're doing anyway, so make 'em however you want to!

Let's do the leaves first.

Since this is the leaf section, apparently.

There is more than one way to make water lily leaves and flowers, of course. This lily pond sculpture is an online class (see the back of the book for details).

Water lilies have captivated artists for centuries. This Chinese carving of a water lily shows a stylized perspective of the flower and very wavy round leaves.

Start with a flattened ball of clay to act as a base that we can press the finished leaf on top of. Press two straight, thick, uncoated wires onto the base clay, parallel to each other. These will remain embedded in the clay until after baking, when we'll remove them and use the channels left behind for stringing the bead onto the necklace.

Roll out a ball of green clay about the size of a cherry tomato (the old-fashioned kind, not one of those ones that look like a little pear). Flatten it with your fingers. Finger-prints all over are dandy. Pinch a bit more around the edges to make them flatter, which makes the leaf look a bit more natural.

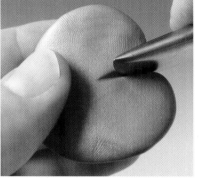

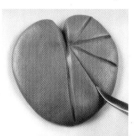

Use a tool to make a deep "V" indentation in the leaf.

Are you wondering how to make that nice green leaf color? Creating good colors is the result of practice. Some folks are naturally better at it than others, but don't worry if it's not your thing. You can become good at it, I promise. This particular green blend is probably the color mix I use the most. It's a mix of Brite Green Pearl, Gold and a little Ultramarine Blue to make it interesting. Try different proportions of each color and see how you like each variation. There's more chitchat about blending colors and mixing in the good ol' Back o' the Book section!

Use a tool to impress a line down the center of the leaf, starting from the wedge and running straight down. (I used the sharper edge of the "Wow It's Awesome" tool. It works great for this part). Press in more lines, like spokes on a wheel, with the center of the "wheel" being the indentation. Make both sides match. Space the lines out – you'll only need about four of these lines on each side.

Now use a needle tool to press in additional, thinner lines in each section.

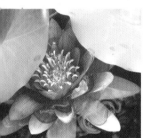

Press the finished leaf onto the base. It's helpful to first add a bit of liquid clay to strengthen the connection. Remember that the wires will be horizontal when the bead is straight, so press the leaf on accordingly.

As usual, a dusting of color will make this leaf really look wonderful. I used a swoosh of Inter-ference Blue mica powder (a PearlEx™ color) in the middle of the leaf to bring out a subtle shimmer. I used brown chalk to add depth to the middle and a dark blue on the lower edge to emphasize the curve.

photo by
gretchen
amberg

Chalk! Have you used this stuff on your polymer yet? It's great – it adds color but not shimmer. Use mica powders when you want color+shine, and chalk when you want just color.

Make another leaf bead. Let's add two leaves onto the base, just for a little variety! Great.

On to the lily flower now! Mix up a color for the flower. Lily flowers come in a variety of colors! I went pink, but you don't have to. Whatever color you make, roll out and flatten some for a base, in the same way as we did for the leaf bead. Press in the wires too.

Cover the base with another flattened circle and press the two together.

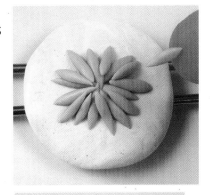

Lily flowers open their petals up first, then the layers of stamens in the middle slowly open to finally reveal the green pod inside. For this flower bead, let's have the petals open, with the stamen cluster in the center.

To make the stamen, mix up some yellow clay with just a touch of green. Now roll out little balls and form them into rice-shaped pieces (more like wild rice - long and narrow).

Press the stamen bits onto the circle. Position them like a sunburst – one end in the center, the other end sticking out.

Add a touch of green powder to the center of your stamen cluster if you want to. Just because it looks good.

The next row of stamen will be sticking up a bit, as if they are just opening. That's actually easier to do than it sounds. Just squeeze a little line of liquid clay all around the outer edge of the stamen circle already on the clay. Then use a tool end to pick up new stamen and press them into the liquid clay, leaning up against the center cluster.

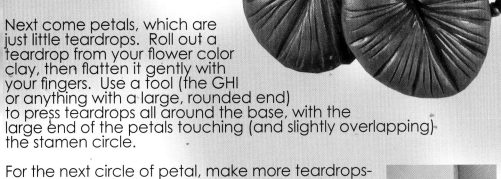

Next come petals, which are just little teardrops. Roll out a teardrop from your flower color clay, then flatten it gently with your fingers. Use a tool (the GHI or anything with a large, rounded end) to press teardrops all around the base, with the large end of the petals touching (and slightly overlapping) the stamen circle.

For the next circle of petal, make more teardrops- smaller, about half as big as the other petals. These need to be more curved, like little spoons. Flatten the teardrops with your fingers, then press the petals over something to make them curve – anything with a large, ball end will work (this is a Sculpey tool – they work perfectly for this part).

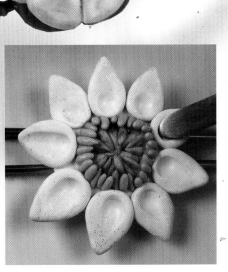

Press them on top of the first layer of petals, using the same ball-ended tool to push them on, in between the larger petals.

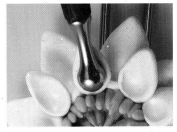

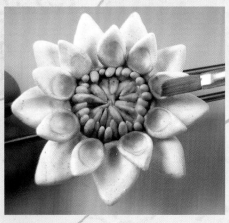

Dust powder (mica or chalk) around the base of the petals. Clean your brush, and use the clean brush to blend the color up into the petals so that it fades gently. Nice, isn't it?

As we chatted about already, lily flowers become lily pods – weird brown circles with seeds peeking out from little holes. They're actually rather sculpturally interesting, and definitely a good addition to our lineup of beads.

So, make a base in the same way as we've already done, this time with brown clay (or you could make a green pod – they're green before they turn brown... it's up to you). Same parallel wires as usual, too.

To make the bottom of the pod, flatten a ball of clay over your thumb to make a shallow bowl. Keep the pod thick and the indentation shallow.

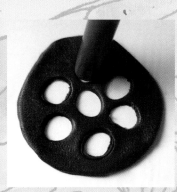

Roll out a thin sheet of brown clay and cut it into a circle the same size as the bowl (so it will fit over the bowl when we're ready).

Use a straw to cut holes out of the circle. Just press the straw down and thwoop! The clay circle will be stuck inside the straw. Clever, huh?

Carefully hold the holey circle over the pod and use a needle tool to mark dots on the pod where each hole is, so we'll know where to place the seeds.

Make seeds from a mixture of green clay with some of the pod brown added. From this mix, roll out little balls and place them on the marked dots. Position the holey clay over the pod and line it up with the seeds so that they all peek out of the holes.

Press the edges of the top circle down to connect with the pod beneath. Use your fingertip to gently rub the edges together to make them one. It looks nice if you press a tool around the edge to create little lines (almost like the ridges on a pie crust).

Now tweak it! Use your fingers to push the pod and make it look more interesting! Perfect.

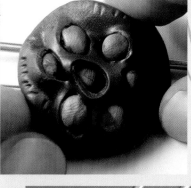

One more bead in this series – a flower bud. It's very simple. Make a base (green clay again), with the wires added, of course. Press another flattened circle of green clay on top of the base.

Now roll out a ball of pink clay and flatten it just a little – make it look kinda' like a mint candy. Add it to the green circle. Press to attach.

Use your fingers to flute the green clay all around the pink blob – like a ruffley skirt.

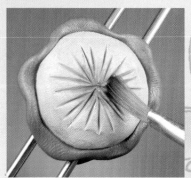

Use a needle tool to draw lines in the center of the bud – that ol' starburst pattern again (mimicking the way we added the stamen in the flower, this is just a simpler version). Use powder to deepen the center of the bud.

This bud will just have one row of petals opening up. Make flat teardrops for the petals, then press the wide end against your finger to flatten the round into a straight edge.

Press the flat, wide ends of each petal onto the clay, all around the pink ball. Push the petals towards the center, with just a tweak or two to make the petals look like the bud is just beginning to open up.

A light dusting of green powder around the bottom of the petals, closest to the green clay, adds a freshness that's just right for a bud.

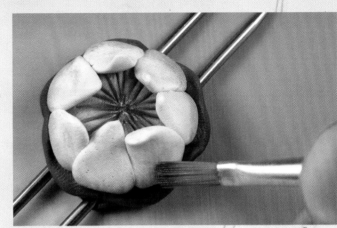

And just like that you have a full necklace-worth of beads! Bake them all. Once they're cooled, you can string them together. First, of course, pull out the wires (use pliers and twist first to break the grip of clay and wire).

Oh, and guess where some stringing tips are? Yup! In the back of the book! Happy stringing!

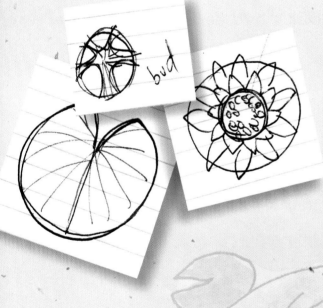

Water lilies really are an interesting subject to explore artistically. I find I come back to those round leaves and bright flowers often. This rendition of water lilies is done in a stained glass style. (We'll explore that technique a little later in the book).

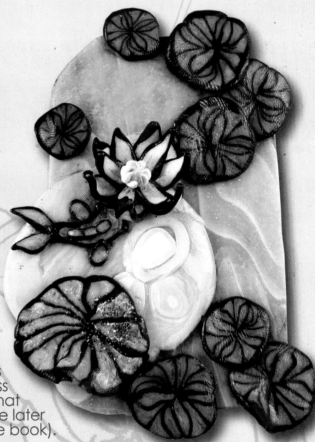

# carved leaves

One of the things that keeps me creatively satisfied with polymer as my artistic medium of choice is its versatility. It can mimic the look of so many other materials. In this book we'll be exploring some of those by imitating leather, stone, ceramics, metal... but right now, you wanna join me in faking the look of carved wood?

For this project, we'll use UltraLight Sculpey™. UltraLight is a weird kind of polymer clay. It's like a big marshmallow. You'll notice when you open the package and try to play with it, that it doesn't really behave like you're used to. That's ok, we're not going to use it in the way that you're used to. We're going to carve it. Carving polymer is a wonderful way to add to your creative options without needing new supplies, new tools or new specialized skills.

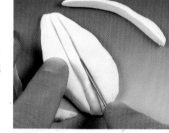

Since UltraLight does not sculpt in the same way as regular polymer, let's start instead by cutting a slice from the clay block (right out of the package), just a little thicker than you'd like your finished leaf to be. (Shape it by gently flattening it in your palms, then trimming away the edges with a blade until you have the leaf shape you intend. This one is a variation of the "Favorite Leaf" shape. We'll add as many details as possible now, to be refined later by carving.

Use a needle tool to add a centerline, (actually two lines), pressed down the center, close together.

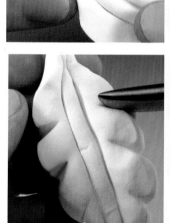

Gently squeeze/pull the clay to create a stem at the top of the leaf. Keep it thick, since the stringing hole will be going through there.

Use a tool to press notches into the edges, in the same way that we did for the "favorite" leaf. So far it should look like a clumsy version, that's ok. Don't overwork it! Just get the basic details in place and move on!

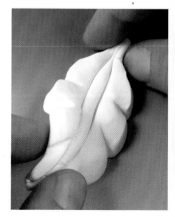

Now give the leaf a tweak, to twist it into a more lively shape!

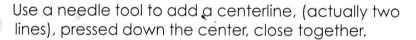
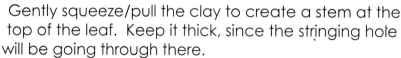
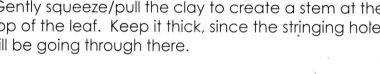
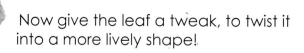

There are other leaf shapes that work well with this carving technique. This one is based on the "forest" leaf pattern. Use your needle tool to press in the centerlines, and the vein lines.

This one is a variation of the water lily leaf. Start with a circle, press in the two centerlines with your needle tool, and pull out a stem.

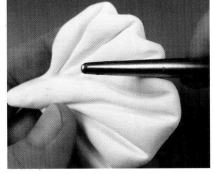

Press in more lines, like spokes in a wheel, on both sides of the centerlines. Use a tool to press indentations, along the edge of the leaf, in between each of the lines.

If you anticipate using the leaves as focal beads, you should also make a few carved spacer beads to go with them. Gently shape a small bit of UltraLite clay into a ball, then flatten it slightly. Make several of these, in varying sizes. Just do it.

Now go bake your leaves! Same time and temperature as usual. Let them cool.

Now gather up some band-aids, cuz it's carving time!

Make sure you use a new craft knife blade to carve with. And I do mean NEW. When the blade gets dull it fights the clay and then the carving is not so fun.

When you carve, aim the blade away from your eyes and arteries, silly. Just make short, shallow cuts all over the surface of the leaf. Cut into the notches and along the edges. Every surface should be cut, if you can, for a consistent, whittled look.

The most difficult cuts are in the center line area, but if you just use the tip of your blade to cut little chips out of either side of the lines, that usually works well. You can also use the widest "U" blade of a linoleum carving tool, if you have one (I've got some more info about that tool coming up, stay tuned...).

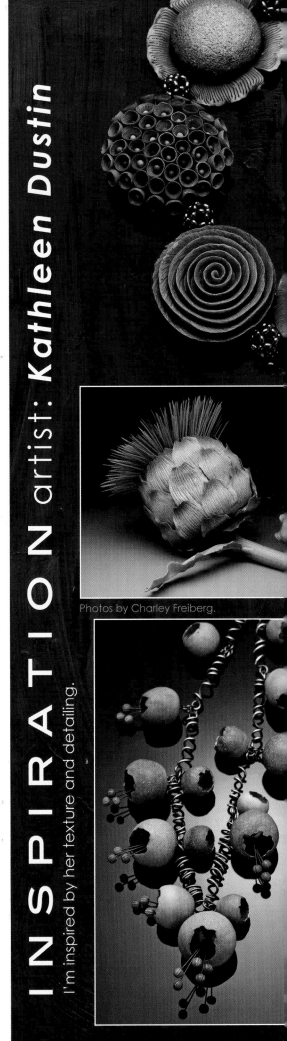

INSPIRATION artist: *Kathleen Dustin*

I'm inspired by her texture and detailing.

Photos by Charley Freiberg.

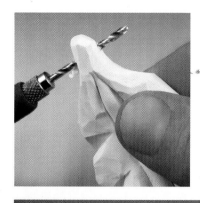

Carve the spacer beads too.

Use a little hand-held drill to make a hole through the stem for stringing. (Another tool... back o' the book... you know....)

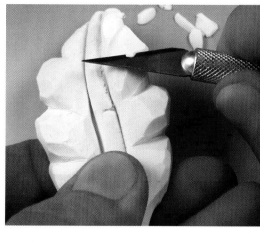

You can leave the carved leaves white, but that's kinda' boring. I like to paint mine. Acrylic paint works best since it combines with polymer very well and it's permanent when it dries. There are several ways that you can paint the leaves. If you want to mimic the look of wood, take some brown paint, add water to make a soupy mix and brush it on. Use a sponge or paper towel to dab any area where the paint is too thick or too runny.

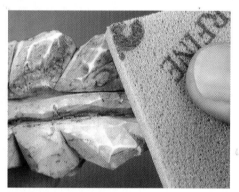

Another way is to paint with more realistic colors, usually green (unless it's autumn). Apply it in the same way. If you want, you can create several shades of greens and brush them on in different areas for variety.

One other way is to keep the paint thick and completely coat the piece. Obviously it could be any color with this method. Try painting on several layers in different colors and sanding them away to reveal the coats of paint beneath if you want an 'antique' effect (and then pretend you found it at an antique shop in Paris, remember to discuss your 'find' in a pretentious accent for maximum amusement).

Speaking of standing, once your paint is dry (whichever painting variation you chose), use a fine grit sandpaper to ruboff a little paint along all the carved edges. Just run the sandpaper lightly over the whole piece! It will really enhance the appreciation of the carved effect! Make sure you sand the spacer beads too, or they'll feel left out.

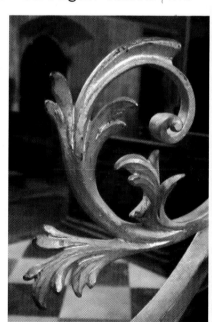

You're done! String them up on ribbon or cord and pretend you're a tree.

Feeling pretty confident with your carving? Try something a little more challenging - maybe something like this carved flouncy thing. It's something I saw in a medieval church in Prague (Please imagine that in a pretentious accent).

# ferny leaves

Let's chat about ferns for a bit, shall we? I love ferns. They're really lovely. And ferny. There are lots of things we could create using ferns for inspiration. Alas, we'll only have space for a few, but feel free to continue on a fern kick even after I move on to other things (I'm totally cool with that).

ferns have been around a long long time as this fossil clearly shows. You can make a fossil fern too! Just press a real fern leaf into some polymer, then bake the polymer. Add a touch of paint, and instant ancient-ness!

Let's make a ridiculously easy cane to use for fern leaves, then use wire to assemble them into a frond. Don't you like the word 'frond'?! It's fun to say. I like to toss it inappropriately into conversations, from time to time. You should try it, just for giggles. "I got the cutest frond to go with my new shoes," you could say. Or possibly not. Maybe that's just too silly. Ok, back to serious creativity.

One thing about ferns is that they usually have a thin stem that lots of individual leaves grow from. That makes them look rather delicate. It also makes them a little harder to create from polymer alone and have it be strong enough. That's where the wire comes in - luckily, wire and polymer work well together, and wire is both strong and delicate! So let's play with a design concept or two that combines clay and wire to create some ferny things.

To make the leaf cane, just gather up some scraps of green clay - assorted shades of light and dark greens are best - and throw in some white or yellow or ecru scraps too so there will be plenty of contrast in the mix. You don't need much clay for this - a wad about the size of a hard-boiled egg yolk is just right. Gather the scraps, flatten them into a pancake, and run that through your clay-conditioning machine (set at the widest setting). Rip the resulting sheet of clay in half. Stack the halves, rip this again and stack again. Flatten this mess with your hands (not with the machine), so that it's flat enough to roll up. Roll it up! Lay the roll onto a sheet of gold clay. (Hey, did I tell you that you'll need a small sheet of gold clay? No? Oh, we'll, you'll need a small sheet of gold clay. Get on that, will ya?) Trim the sides of the clay sheet even with the ends of the roll, then wrap the gold clay around the roll - just enough to cover it, no overlapping.

Cut this wrapped roll in half lengthwise, and cut each half in half lengthwise also, to make four skinny wedges. Take one of the cut wedges, and press the point down against your work surface to flatten it and manipulate the clay until the wedge becomes a half circle.

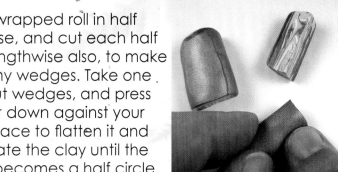

Pick it up and keep manipulating the clay, pulling and pinching the edges towards each other to sminch it into a teardrop with all the green bits inside and only gold clay on the outside. You got all that? Don' t worry, it's easier than it sounds.

Use a blade to slice off the end. Pretty? Good. Slice this cane into three equal sections. Don't use a ruler or anything, just eyeball it. Stack them on top of each other, pointy ends together. Press the pointy ends together firmly.

Gently pinch the fat ends together into a point. You should now have a leaf shape. Reduce the size of the cane if you want smaller leaves (back o' the book for more on that process, if you need it).

Cut slices to make at least six leaves - you can make more if you want to, I made eight. The slices should be about as thick as a ten cent coin. Smooth the cut edges by pressing each slice gently with your fingers.

Use a needle tool to make a hole in one end of each leaf. Don't make the hole too near the tip of the clay, put it a little more towards the middle, for strength.

Bake the slices. Thirty minutes is long enough. Let them cool.

Let's make the center stem - we will wire the leaves onto this. If you don't know much about wire working, don't worry, the basics are very simple. A special hammer and block are nice to have, but not necessary. If you find you like wire working, then you can buy more tools later. For now, go find a hammer and something smooth and hard to hammer on (like a brick or a big, smooth rock, or the cement floor in your garage).

Snip off about 6 or 7 inches of 20 gauge wire. I used copper, but any color metal will work.

Use round-nose pliers to bend a loose curl in the end of the wire. Shape the wire so that it arches ever so gently - like a fern frond! The wire should be long enough for you to add all the leaves and have some wire sticking up from the top. Now bend a fancy loop or curl at the top with those pliers and snip off any excess with wire cutters.

It's hammer time! Use your hammer to flatten the wire. You want to work the hammer up and down the length of the wire, slowly flattening it. Don't be a wimp, it's ok to pound, just don't go all blacksmith on it, or you'll distort the shape. And guess what? Hammering the wire makes it harder and stronger (it's some science thing, I think), which will make it sturdier when you wear it.

To add the leaves, you'll need thinner wire, 26 or 28 gauge is best. Snip off a long piece of wire, at least 16 - 18 inches. Insert the wire through the hole in one of the leaves (just a little bit, less than an inch should stick through the hole). Pinch both halves of the wire together and then twirl the leaf two or three times to make the wires twist together. Cut off the excess little tail of untwisted wire. Wrap the twisted wire around the flattened wire frondstem. Go ahead and wrap a couple twists more (which will now be the regular, untwisted wire), to secure this first leaf to the stem.

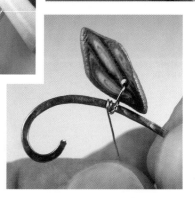

Slip another leaf onto the wire. Give the leaf one full twirl to add some space and to hold the leaf steady. Wrap more wire around the stem to get the wire up and away from the leaves you've just attached so that there will be space to add two more leaves.

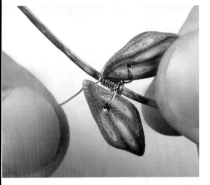

Add two more leaves in the same way. Well, almost. Leave a little more wire showing when you slip a leaf on, and twist it so that the leaf sticks out from the frond wire more than the leaves below it. Perfecto.

Keep going until all the leaves you want to add, are added.

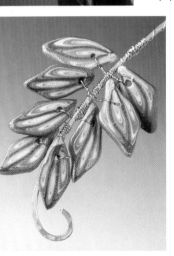

Once all the leaves are wired on, continue to wrap the rest of the wire up the frond stem as far as you like it. Finish it by wrapping tightly, snipping the excess (if there is any) and using pliers to press the end firmly down. A drop of glue on the end will help keep the end in place.

Jump rings around the upper loop will secure a chain for wearing this pendant. Or tie on some ribbons to it, if you prefer.

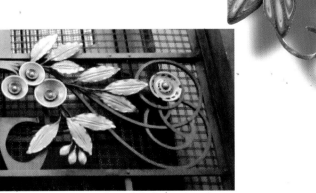

This Art Nouveau flourish is not a fern, but I just love those curls, don't you?

INSPIRATION artist: *Daniela D'Uva*

I'm inspired by her curvaceous wirework.

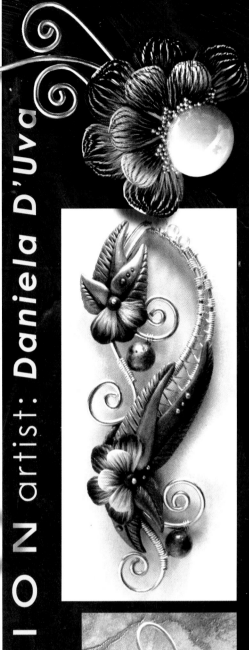

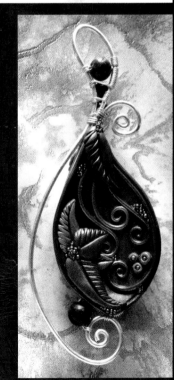

## more ferny stuff

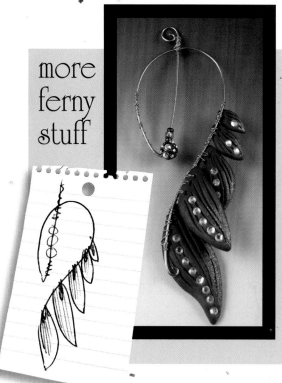

This piece was done in the same way as the project we just got finished chatting about. Clay leaves with holes added so that it can be wired to a main stem. In this case, I got fancy with the wire curving, and also slipped on some beads before attaching the leaves. I left the wire round (so, no hammertime).

A note about the surface treatments used on the fern leaflets – I brushed blue chalk on the edges closest to the wire, and added glitter to the outer edges. For best results, gently smear on a little Bake & Bond™ (a Sculpey product) as if you were rubbing in lotion, right where you want the glitter to go, then dab the glitter on with your fingertip. The B&B is a heat-activated white glue made especially to work with polymer. It'll grab that glitter and keep it from flaking off later.

Oh, and the rhinestones down each leaf are glass (plastic will melt and go all Salvador Dali on you in the oven). Flat-backed crystals with a heat-set glue (like Swarovski Hot Fix™ crystals) are best – just press them firmly in place and they'll glue themselves on when you bake the leaves. Cool, huh?

## fiddleheads

Those lovely little curled-up baby fern fronds are called fiddleheads. I have absolutely no idea why.

From a design point-of-view, they are a delight -- full of potential and mystery. Here's one way to make them. Roll out a snake of green clay. Roll out lots of little ovals of clay, some really short, some a little longer. Press these onto the edge of the snake, starting at the tip of the snake. Begin with the shortest, and work up to the longest. Press them one right next to the other. Press them on firmly (but no smushing), so it kinda' looks like fringe.

With your finger, bend the ends of the clay fringe over gently.

Start at the tip and roll it up, like a cinnamon bun.

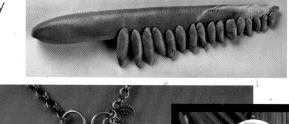

Now the designing is up to you – cluster a few together and maybe add a small fern leaf or two. Poke holes if you want to wire it up, or just add a hanging hook if you like it as is. If you are a bead-embroiderer, you can press it onto a flat sheet of clay to give yourself an area to bead around. Lots of possibilities, aren't there?

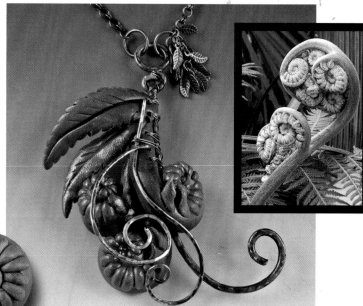

28

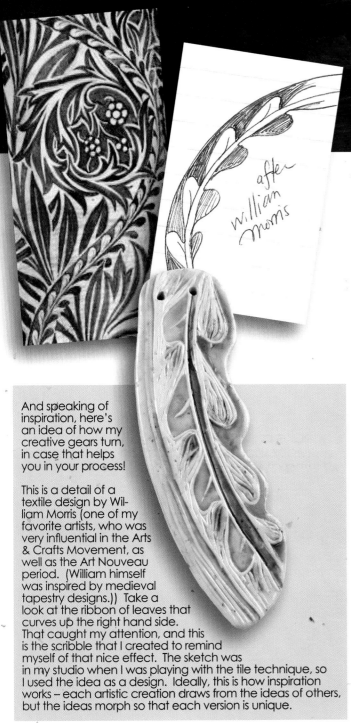

## How inspiration evolves into creation: a real-life scenario

Ok, so HOW exactly an idea is inspired and how it becomes a finished creation is something all us artist-types are interested in. Here's a nice little story of that process. Of course I will be the heroine of the story, because it's my book, and I can. Also, it happened to me, so that's convenient.

Once upon a time, not so long ago, a loveable artist (that's me) was wandering somewhere (it's not important where, and also I don't remember) and was struck (not literally of course) by the beauty of some ceramic tiles that were used in the decoration of a building. The designs were intriguing, in the "Arts & Crafts Movement" style (it's an art thing, Google it). The design was comprised of raised lines with the glazed colors filling each little cell. Later, possibly in some other city (the loveable artist travels a lot), she saw some Motawi tiles (a modern company specializing in handmade Arts & Crafts-style tiles) and knew that somehow she'd have to figure out how to create this awesome look in polymer.

The problem was how to easily make those lovely raised lines – there's some complicated details as to why this was not as easy to do as it seemed, and why doing it in polymer could not be done in the same way as it was done in ceramic, but those details are not important to the story.

While she was mulling over the idea, waiting for inspiration to hit her (again, not literally, sheesh), a meteor crashed through the window and landed in the kitchen! (pssst, this didn't really happen, the story just needed a little excitement). After the loveable artist swept the cosmic debris off the table, she decided to flip through the new Polymer Arts magazine (it was the new issue at the time, not now, this happened a while ago). Sage Bray, the editor had an article showing how to create a very similar look, using beeswax (check out the magazine to see the nifty article if you want to!). Our heroine liked the idea, but was too lazy to go out and get some beeswax and the other stuff, so she just did nothing about it... yet... (oooh, foreshadowing!).

Fast forward to Alaska, on a cruise ship. It was a dark and stormy night, or possibly a calm mid-morning. The artist (still loveable) was part of a Clay Cruise, where another teacher (metal clay artist, Jackie Truty) was creating a similar look! This time in metal clay, using linoleum block and cutter. "Ah ha!!!" thought our hero (or heroine, to be more accurate) this seemed a little closer to the look she was trying to achieve and also less messy. Experiments ensued, modifications were made, results were achieved! Everyone lived happily ever after.

You can see for yourself if you like the look and the way to create it with the project on the next pages!

Sage Bray

And speaking of inspiration, here's an idea of how my creative gears turn, in case that helps you in your process!

This is a detail of a textile design by William Morris (one of my favorite artists, who was very influential in the Arts & Crafts Movement, as well as the Art Nouveau period. (William himself was inspired by medieval tapestry designs.)) Take a look at the ribbon of leaves that curves up the right hand side. That caught my attention, and this is the scribble that I created to remind myself of that nice effect. The sketch was in my studio when I was playing with the tile technique, so I used the idea as a design. Ideally, this is how inspiration works – each artistic creation draws from the ideas of others, but the ideas morph so that each version is unique.

Jackie Truty

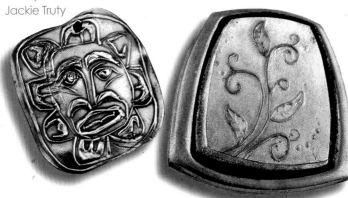

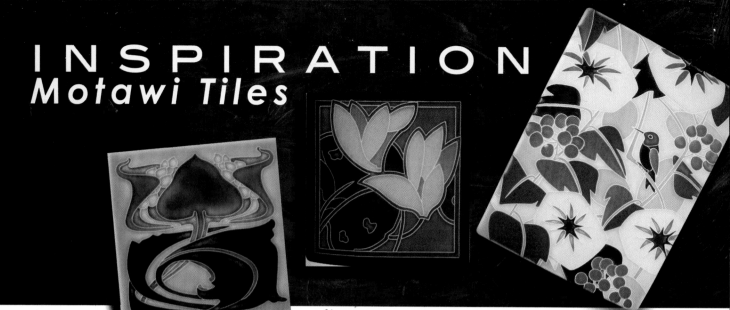

If you read the previous page, you'll know the backstory to this technique. It was a gripping tale of intrigue! If you didn't read the previous page, well... you still can do this project, I guess.

You'll need a slab of clay to carve. And something to carve with. The carving tool of choice is a Speedball Lino Carving tool (with a small V-notched blade – they're usually always sold together).

Roll out a bit of scrap clay on the widest setting of your clay-conditioning machine. Make it about twice as long as you'll need, so you can cut it in half and stack the two pieces. Make sure the top surface is smooth. Bake it for about 30 minutes. Let it cool.

Use a pencil to sketch a simple line drawing onto the surface of the clay. With the carving tool, carefully carve down the center of each line. (There are a few safety features and carving tricks you will want to know first – sneak off to the back o' the book and find out!)

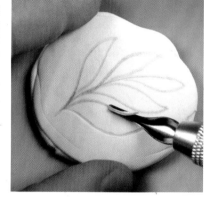

Roll out a small sheet of clay in the color you'll want the tile to be – I suggest something white-ish, so it looks like ceramic, or porcelain.

Use a fine mister to spritz a bit of water onto the carved design as a resist (a resist will help keep the clay from sticking to the design). Press the tile clay sheet onto the design and press it firmly so the clay will fill in those carved lines (that's where the magic happens).

Peel it off! Tah dah!!! If you've pressed well you'll have a raised impression of the design.

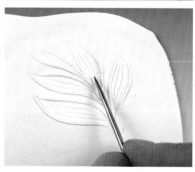

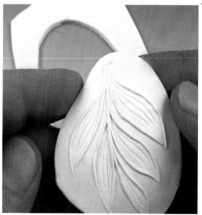

If you want to, you can add other small details. For example, I used a needle tool to press in small lines in each leaf.

Use a tool to cut around the design in whatever shape you want your pendant to be. Smooth along the edges.

Add a hanging hole if you want.

Bake the tile. When it's cool, coat it with a glaze – satin or semi-gloss is good (I've got some glaze info in the back of the book, of course!)

Ok, so here comes the fun part. We're going to make a special coloring liquid – it will pool in the cells nicely and it really, really looks like ceramic glaze! Really.

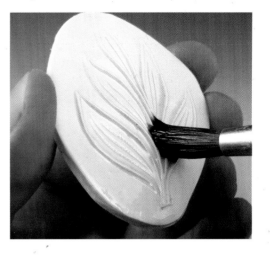

Pour a few drops of the same glaze in a small container, then mix a small amount of chalk powder into it. I scrape some of the chalks from their container to dump into the glaze, which means that there are clumps to be mixed in. They dissolve easily, but try to leave a few little specks unmixed – the little dots of color add to the look of glaze when applied. Make as many of these little color glazes as you'll want to color the piece.

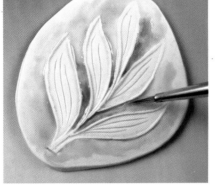

Use a paintbrush to paint in the color glazes. Because of the glaze already on the surface of the pendant, these colors will flow nicely.

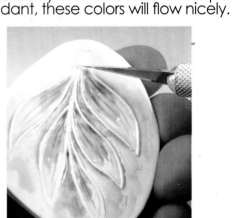

As you paint, any that gets out of its area can be lifted off with a cotton-tipped swab, or the tip of a craft knife.

Let it dry.

Doesn't that look great?!

Vary the clay tile color and the glaze colors for completely different looks!

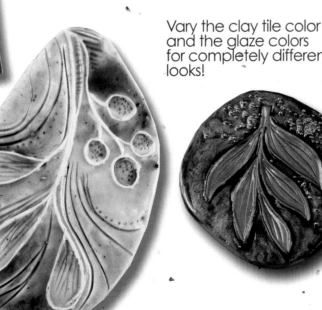

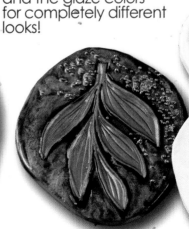

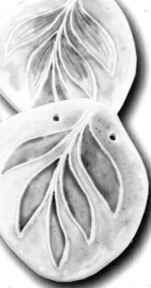

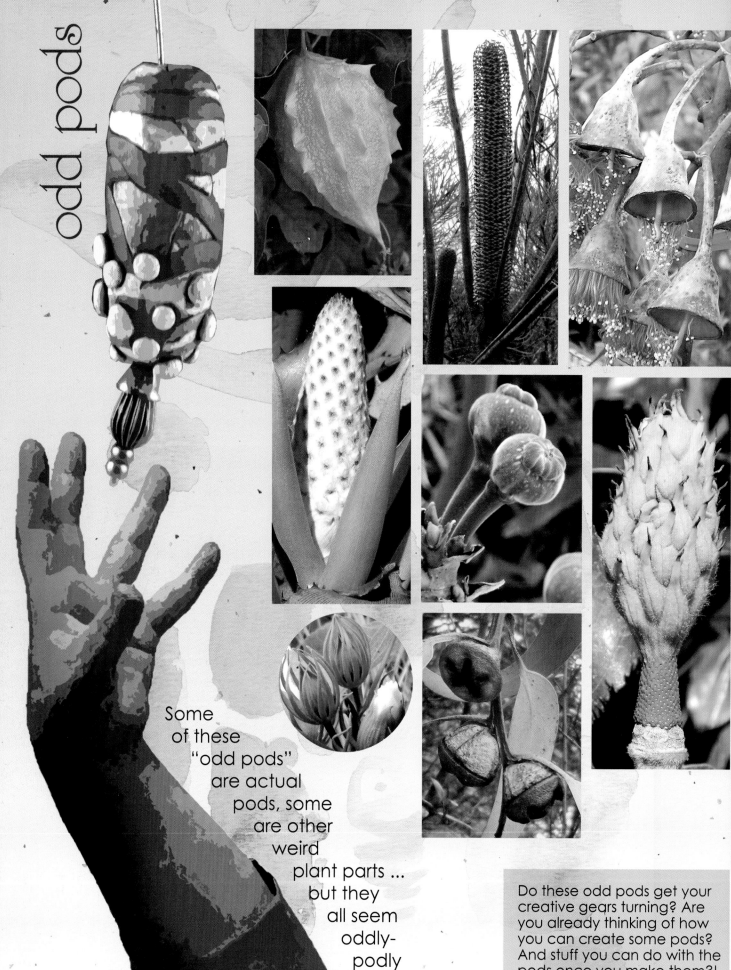

# odd pods

Some
of these
"odd pods"
are actual
pods, some
are other
weird
plant parts ...
but they
all seem
oddly-
podly
to me...

Do these odd pods get your creative gears turning? Are you already thinking of how you can create some pods? And stuff you can do with the pods once you make them?!

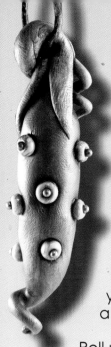

I don't know what kind of pod this is, but it's interesting-looking and easy to make. If you want variety, you can vary the clay color, size and shape of the pod, and bead accents.

Any color will work, but it's fun to use a Skinner blend for this one, the graduation of color works well on a long pod shape. (Check the back o' the book info section if you need a refresher on making Skinner blends!)

Roll up the blend to retain the graduated color and smooth it to make a long oval shape. Pinch and pull one end to a long, thin point. Form the other end into a short stem – more pull and pinch, just not as much pully or pinchy to keep it shorter.

If you want to, curl that tip into a coil. Of course, if you don't want to, you can leave it straight, or not even make a long tip at all. It's your pod, do what you wanna do.

Add beads in the usual way – slip one on a headpin, trim the wire and bend a hook in the end. Press the beads in all over! Up at the stem end, press on some flattened leafy shapes around that stumpy end. Add a tendril if you want to – just roll out a snake of clay and wrap it around a needle tool.

Firmly press the clay (still wrapped around the tool) onto the side of the stem, then gently twist to loosen the tool from the clay. Carefully slip the tool out to leave the tendril attached.

Bake. Add an antiquing patina with acrylic paint to bring out the details if you want to!

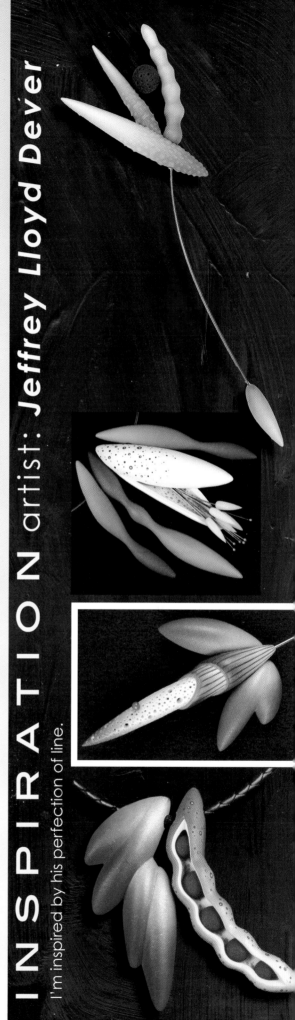

**INSPIRATION** artist: *Jeffrey Lloyd Dever*

I'm inspired by his perfection of line.

# what can you do with pods?

Curled pods are very easy, and very eye-catching because they are sinuous and asymmetrical. Start with a wad of clay that has been mixed from several colors. Rip off bits of clay to create logs – they can be fat or thin, and as long as you want the pod to be. Roll both ends of each log into points. Clump the logs together. Gently roll, squeeze and pinch one end to join and blend all the ends of the logs together into one point. With your fingertip, roll that point into an open curl. For the other end, just gently smoosh the points together. Pierce the pod with a needle tool for later stringing. You can pierce it anywhere, depending on how you want it to hang!

*string them up and wear them*

Stick one in your ear holes (pierced holes, not the kind you hear with, duh)

# INSPIRATION
## artist: *Gail Crossman Moore*
I'm inspired by her wonderful use of multiple media.

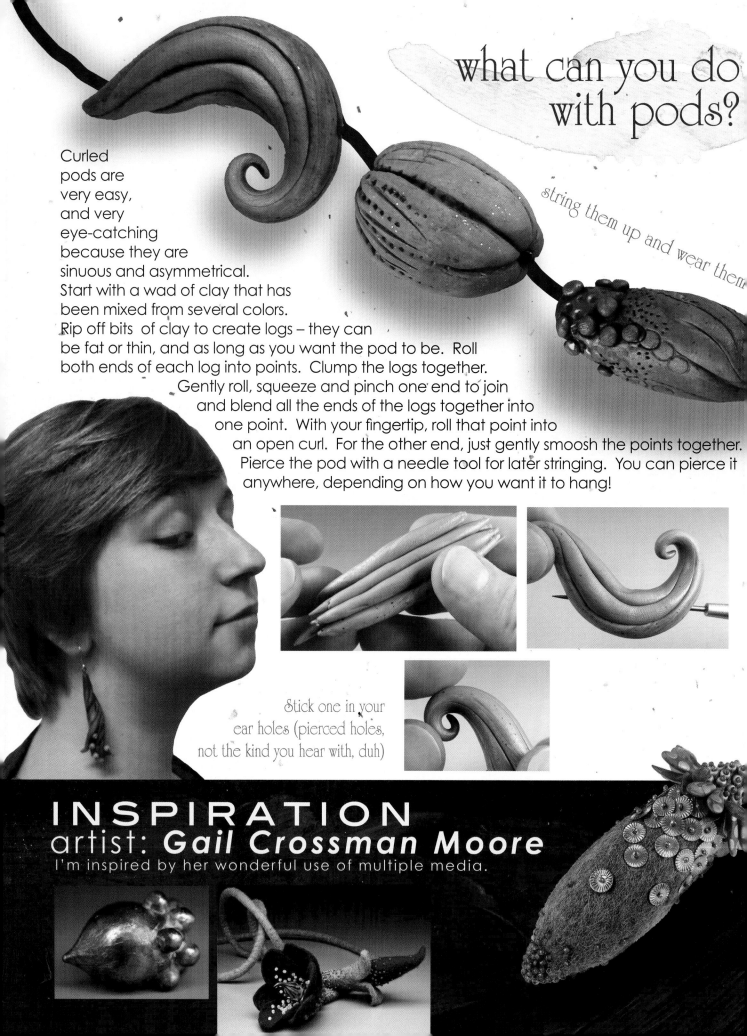

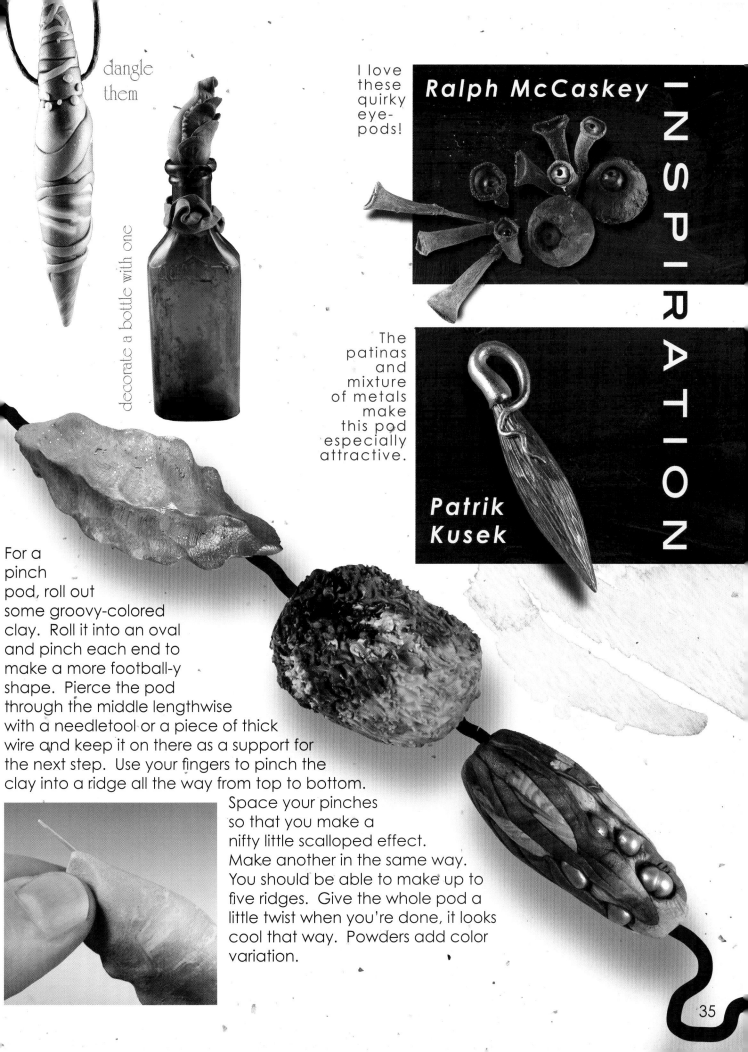

dangle
them

decorate a bottle with one

For a
pinch
pod, roll out
some groovy-colored
clay.  Roll it into an oval
and pinch each end to
make a more football-y
shape.  Pierce the pod
through the middle lengthwise
with a needletool or a piece of thick
wire and keep it on there as a support for
the next step.  Use your fingers to pinch the
clay into a ridge all the way from top to bottom.

Space your pinches
so that you make a
nifty little scalloped effect.
Make another in the same way.
You should be able to make up to
five ridges.  Give the whole pod a
little twist when you're done, it looks
cool that way.  Powders add color
variation.

35

# Fruits & Berries

This section in the world of flora really ought to have a lot more pages, but I'm all excited to get on to flowers, so this will just be brief. You can have more fun with fruits and berries on your own time, ok?

Berries are fun to create because they are intensity in a small package. Design, color, texture... berries have it all. Plus you can create them in any hue or shape that you want and just make up a name and say it's a newly discovered rainforest berry – who's gonna know? There's a new rainforest plant thing discovered every other month. Oh, and don't forget to say it's an anti-oxidant... I'm not exactly sure what that's all about, but it really adds some credibility to your story.

Obviously you can roll out a ball of clay, stick a stem on it and call it a berry, but let's have a bit more imagination with this. How about an interesting clay mix that makes the berries seem temptingly delicious. Yeah, there's a mix for that!

Start with some translucent clay. Roll it out into a sheet and add some embossing powder (any dark color), and some chalk powder (I chose a few reddish colors). Fold the clay around this mess and run it through your clay-conditioning machine. Keep folding and running it through until the color and the powder is mixed thoroughly. This bit of chalk will provide color but keep the clay looking luminous and natural (the little embossing powder specs really add a lot of that realism, don't you think?).

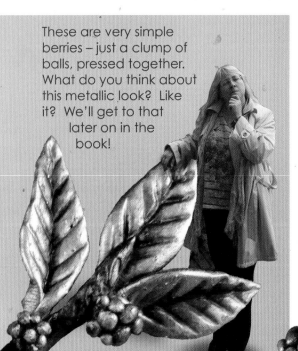

These are very simple berries – just a clump of balls, pressed together. What do you think about this metallic look? Like it? We'll get to that later on in the book!

Roll the clay into balls of almost the same size – vary the sizes a bit for realism. Pierce the ball through the center with a needletool (cuz we're gonna wire up in a minute). While the berry is on the needle tool, brush more chalk on to add color variations to each berry – a swipe of green on those still ripening, some deeper reds on the ones ready to eat...

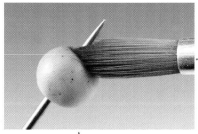

Bake 'em. Once they're done, add a clear glaze to add that succulent shiny-ness!

Now, you can do any number of things with these, but adding them to wire "branches" for a necklace or brooch is kinda fun.

So let's turn those berries into something. Putting the berries onto wire stems and wrapping the whole thing up into a lovely clump could be fun. Let's try it.

Start with some thicker wire – I used 20 gauge copper wire. Snip off about six inches, then use a round-nose plier to wrap the end of the wire into a curl or two. Keep the curl small and tight.

Wrap a bit of 28 gauge wire around the thicker wire, near the curl. Slip one of the berry beads onto the wires. (It should slip over both wires if you made the hole big enough. If you didn't, too bad. Oh, no, wait... you can just make the hole bigger with a little hand-held drill. Easy peasy.)

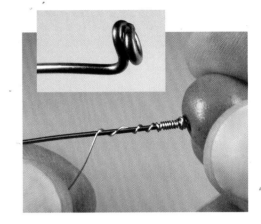

Push the berry down and wrap the thin wire around and around right above the berry to make a nice wad. This will keep the berry at the bottom of the stem where it belongs. Continue to wrap the thin wire up the stem. The wrap can be tight and together, or loose and all over the place!

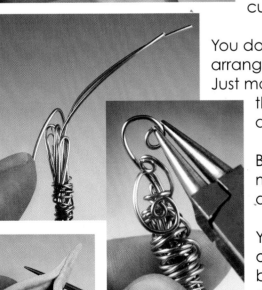

Repeat the process with all the berries. Bundle the wired berries together and adjust their lengths for maximum interesting-looking-ness. Wrap all those together with thicker wire.

To make the top look finished, bend over all but two of the wires and continue wrapping to encase them. The bent-over ends will make up the top of the stem. Using the pliers again to twirl those two loose wires into curls will just add more fun to the look.

You don't have to add a leaf to the arrangement, but it might look nice. Just make one and add a hold through the stem so it can be more easily added. Just wire it onto the clump!

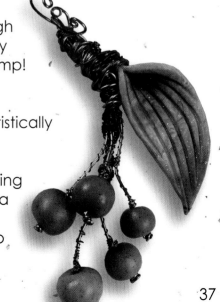

Bend and spread and adjust to make your berry bundle look artistically amazing.

You can wire or glue a pin backing onto the backside to wear it as a brooch, or you can slip a chain or ribbon through one of the top loops to wear it as a necklace. **Berry nice!**

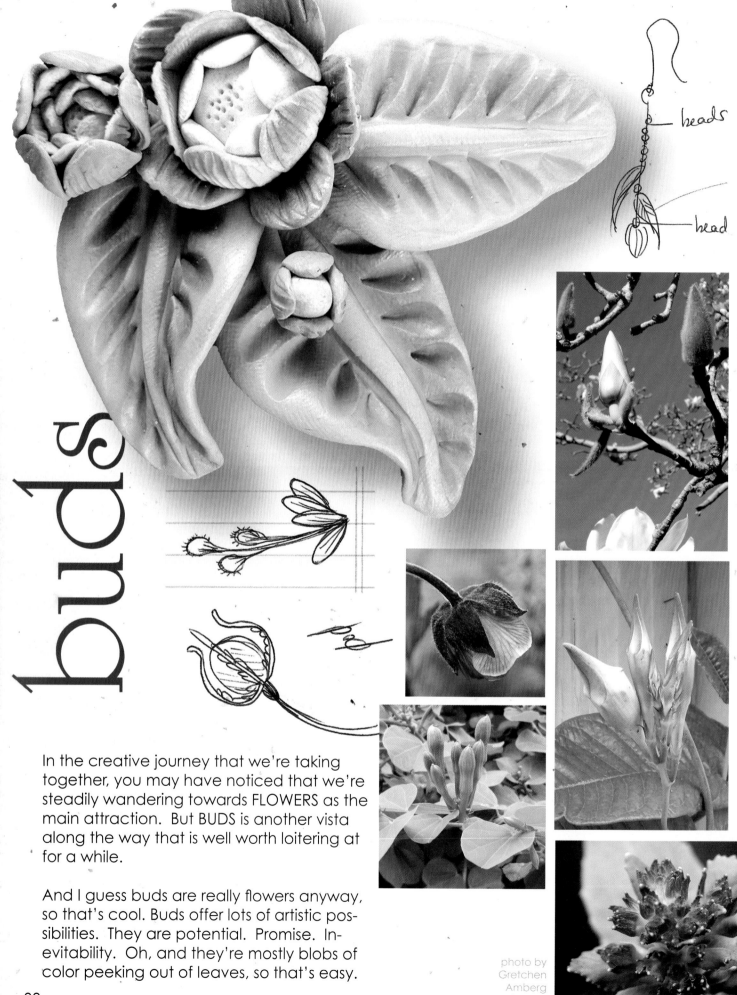

heads

head

# buds

In the creative journey that we're taking together, you may have noticed that we're steadily wandering towards FLOWERS as the main attraction.  But BUDS is another vista along the way that is well worth loitering at for a while.

And I guess buds are really flowers anyway, so that's cool. Buds offer lots of artistic possibilities.  They are potential.  Promise.  Inevitability.  Oh, and they're mostly blobs of color peeking out of leaves, so that's easy.

photo by Gretchen Amberg

Let's play with three different bud projects – what you'll do with them is up to you. They could decorate a wall piece, or a covered vessel, or become a pendant or focal piece, or a brooch, or made smaller for earrings. (Hey, if you're curious about covered vessel or wall piece details... head for the back o' the book, babe!)

Ok, the first bud is a shy bud. I don't know why.

Start with a bit of clay that will be the core of the bud. I chose a buttery yellow, but any color can work. Roll it into a teardrop.

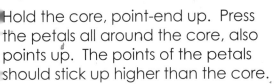

Now use a different color for petals. Roll out five little teardrops (or six if you prefer) and flatten them with your fingers.

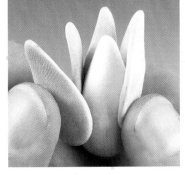

Hold the core, point-end up. Press the petals all around the core, also points up. The points of the petals should stick up higher than the core.

Squeeze the bud in the middle to pinch the petals together. You'll be removing this bottom part later. For now leave it as a handle to have something to hold on to.

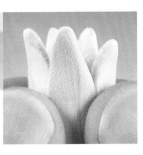

Make some more teardrops out of green clay, just a little larger than the petals. Press them onto the bud all around, pointy-side up too. They should stick up above the petals. (In case you were wondering, these are called sepals. Please make a note of it, it will be on the test at the end). Squeeze everything again, in the same spot.

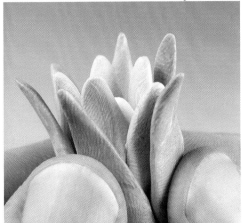

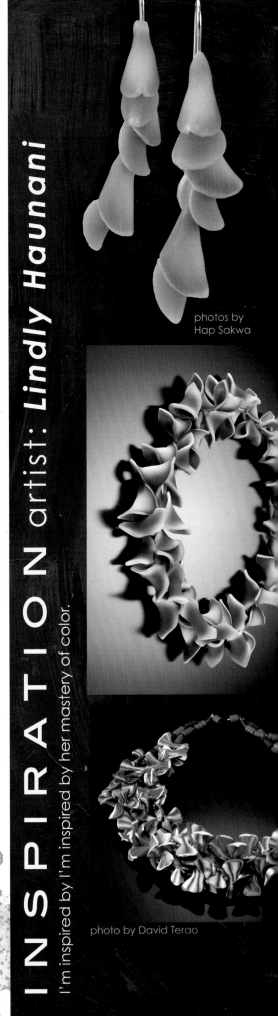

INSPIRATION artist: Lindly Haunani

I'm inspired by I'm inspired by her mastery of color.

photos by Hap Sakwa

photo by David Terao

Keep pinching to reduce the bud, and at the same time create a stem. Pinch off any excess.

Gently open up the petals and sepals (so, it's a shy bud, but a little coy, too).

Make a leaf, whichever one you like. Press the stem of the bud into the leaf.

Add any powders you want in order to color and shimmer the piece. Sweet.

That was fun! So now do you want to make another bud? Me too! This next one is a perky bud.

But first, I think we should make a branch for these buds to grow from, for variety's sake. Mix up some branchy colors, like brown and gold and ecru, and keep the mix streaky. Roll out a snake, but keep it rough (it will look more natural that way). Twist it into a branch-like shape.

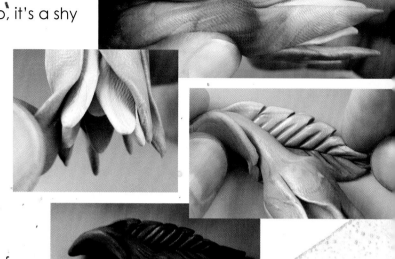

Okay, now, this next bud starts as another teardrop, but much smaller. Also, position the teardrop roundy-side up this time. Instead of petals, let's go straight to the sepals – make five or six green teardrops, and press them all around the core, roundy-side up. Squeeze at the pointy end just enough to press everything together.

Roll a bit of the branch-colored clay into a ball and smoosh it flat. Wrap that around the pointy bottom of the bud like a bandage. Squeeze and roll the brown clay to form it into a stem at the base of the bud.

Pinch off any excess stem and then press it onto the branch. Make more! Press them on too! You can pull open the green sepals to reveal the bud, or push them together to make the bud just opening. Add a touch of color to the center of the bud to make it look more interesting. Oh and why not add a few leaves to the branch as well! The "generic" leaf works great for this one. Just press them.

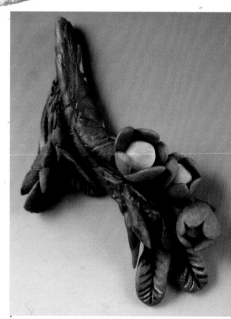

# Bud branch complete!

Ok, just enough room for one more bud. This one is a drama bud! It starts with a rounded center core, just like the perky bud, only a little larger. Add some dots with a needletool if you want. And throw a little powder for fun.

Add the five petals – they are indeed petals this time, not sepals, so make them a flowery color. Now make another five teardrops, bigger than the first ring of petals. Before you press them on, use a tool to make lines on one side, from top to bottom. Now press those on all around (it looks best if you position those petals in between the first circle of petals instead of directly behind each one).

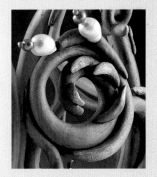

You can use pearls as buds. What other things could you use?

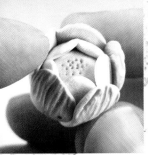

Now it's sepal time! You know, that word is just silly. Let's call 'em 'leaflets' for the rest of the book, ok? Roll out five of those, just a bit bigger than the last ring of petals. Add the lines to these too – on both sides of the leaflets! Now press them all around (and position them in between, not behind, the previous petals). Squeeze the leaflets to attach them and also to make them open up. Nifty.

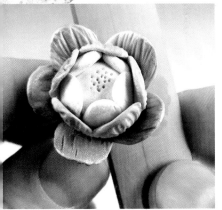

Use powders to make the colors more intense. Use a blade to slice the bud off the excess clay. Set that aside for the moment.

Make some awesome leaves for the bud to live on. These are a variation on the 'Generic' leaf. Start with a big leaf shape, and instead of pressing one line down the center, I made two center lines to create a ridge in the middle. Then use a tool to press lines on each side in the usual leafy way. A dusting of chalk powder adds a velvety color that really makes this leaf design pop. Make a few leaves and arrange them together. Don't forget that tweaking and twisting the edges makes the leaves look more lifelike!

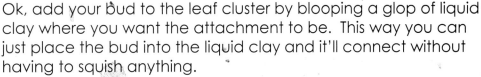

Ok, add your bud to the leaf cluster by blooping a glop of liquid clay where you want the attachment to be. This way you can just place the bud into the liquid clay and it'll connect without having to squish anything.

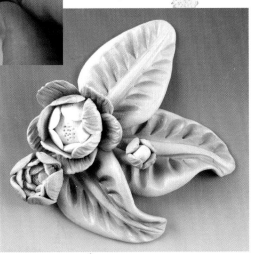

One bud is fine, but three are much better! It's a design thing. So make two more. Make one just a bit smaller by making all the components smaller (that makes sense, huh?). Keep the petals and leaflets all pressed close too.

For the last bud, make one just like the perky bud – small and simple. Doesn't that look good?

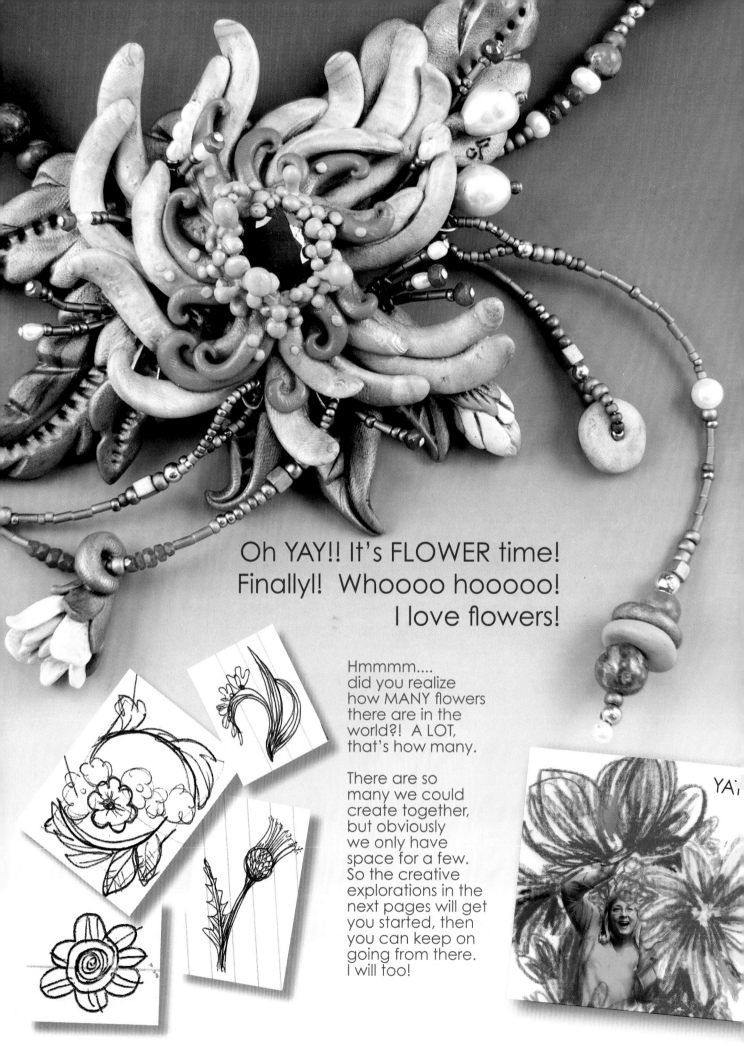

Oh YAY!! It's FLOWER time!
Finally!  Whoooo hooooo!
I love flowers!

Hmmmm....
did you realize
how MANY flowers
there are in the
world?!  A LOT,
that's how many.

There are so
many we could
create together,
but obviously
we only have
space for a few.
So the creative
explorations in the
next pages will get
you started, then
you can keep on
going from there.
I will too!

# groovy flowers

You know those bright, happy daisy-like flowers that were
everywhere in the hippie dippie days of the 1960s?  Well, that's the kind of
flower we'll start with.  This kind of flower is really easy to make –
just flatten a bunch of teardrops and press them around in a circle. Any color
will work.  Thin teardrop petals or thick, short or long, lots or just a few.  Sound fun?
Let's make it more exciting.  Adding stripes to the petals is a great way to add drama,
and making the stripes more soft and subtle is prettier.

This requires a caning trick. Start by making a Skinner blend (that little tidbit is stepped out
for you in the back of the book, if you need that info first). It doesn't need to be a lot of
clay – your sheets of color only need to be about 3-4 inches long/tall.  Once you've made
your blend, fold up clay sheet so it's more narrow, and run that through the pasta machine
to make a long strip.  Roll the strip up tightly into a cylinder (this is usually called a bullseye
cane... just thought you'd want to know that, in case it comes up on the final exam).

Now you've got a log that goes from one
color in the middle to another color on the
outside.  Use your cutting blade to cut in
half lengthwise.  Cut each half in half also
lengthwise.  Wait! Not that way! The other
way! Just kidding.

Take one of the quarters and smoosh the
pointy part of the wedge down on the table
to flatten the section into a half-circle.  Now
use your fingers to pull the clay on the outside
around, encircling the center color.  This will
turn the wedge into a, well, um...
a wedge.  But
the colors get
rearranged,
so that's good.

Repeat with all four
pieces, then stack
them on each other
and squish them
together, thinner pointy ends together.

Reduce this cane by squeezing and pulling. Cut it in half and press one half on top of the other. Manipulate this into a petal shape (teardrop, obviously).

So now just cut slices off the petal cane and soften them with your fingers to take away that cookie-cutter look. At least 8 slices is usually enough.

Roll out a small ball of green clay and flatten it. Press the petals onto this clay, points in.

If your groovy flower stays like this, it'll look like it's just too lazy to move. Sometimes that's just fine, but let's add a bit of realism to the design! Pick it up and lay the center over a ball-tipped tool. (If you don't have one in your tool clump, anything that has a big, rounded end will work. Check in your kitchen drawer, there's probably something in there.) Press the flower around the ball to make it cup nicely.

While it's still on the tool, you can press the tool onto whatever clay base you like. Twisting the tool to break the grab of the clay will allow you to remove the tool. Excellent dude!

Now add stamen to the middle. These can be any number of things from fibers to beads to headpins. Let's just make some out of clay. Just roll out a bunch of little ovals. Gloop some liquid clay into the center of the flower and then use the edge of a tool to pick each little clay bit up and plonk it down into the goop.

Fill up the center, and you're done!

You can vary the patterns of the petals endlessly! Experiment and see what you come up with!

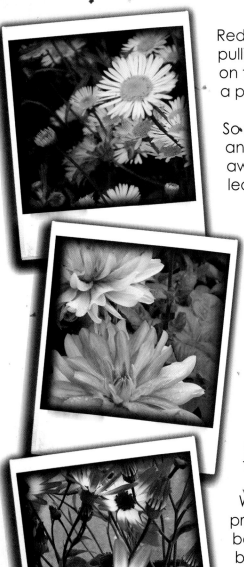

Here's one variation to get ya started. It uses the leftovers of the cane we just made. Roll out a sheet of clay in a color that will go with the cane remnant. Make the sheet thick. Lay the cane wedge on the sheet. Cut the sheet to the same width, and a bit longer on the top (rounded end). Add a section of clay above the cane, then lay another sheet of clay over the top.

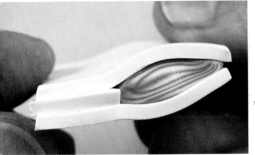

Cut this in half and press one half on top of the other. Press them together and shape into a petal (teardrop). Reduce the size by pressing and pulling.

Cut a petal slice and then use a needle tool to drag the color to feather it, and add texture. Add more lines to the whole surface of the petal if you like!

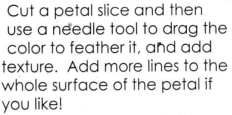

Add stamens and powder if you want to!

When you bake your groovy flowers, make sure you prop up the petals with a bit of tissue paper to hold them up while they harden, otherwise you'll get droopage ...nobody wants droopage.

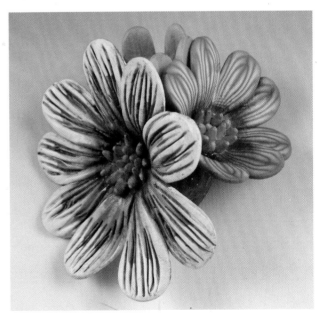

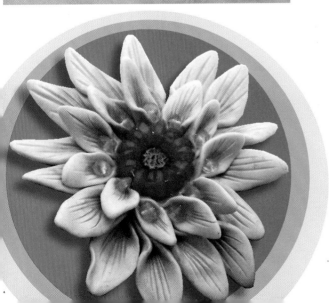

Groovy flowers like daisies and sunflowers look really good with added beads in the petals or in the center. Play with that!

# superstar flowers

Many flowers follow a kind of star pattern with five or six pointy-tipped petals. Let's run through the steps to make one variety and you can experiment with other versions.

Start by making six balls of equal size, then rolling/pinching them so that they have blunt points on each end– little american-style footballs.

To turn the footballs into petals, flatten each ball very flat – as thin as a dime – and make the edges even thinner. It's good if the edges are uneven and a little rippley.

Use a tool to drag shallow lines across the surface of the petals. Pinch the rounded end to curl the petal.

Press three of the petals together, one next to the other, to make half a flower. Do the same with the other three. Now push the two halves together. This will make a clump underneath, that's ok.

At this point, it's best to press the flower onto the background or the leaf arrangement that it will be part of. All the details that come next are better done with the flower in place, rather than having to move it and attach it later, which could mess up what you're adding next. I just made a background panel, added a few leaves, then pressed the flower on.

Ok, now add powder in the pockets of the petals. Hey, wanna add more glamour? or more glimmer? Glitter! Use a smear of Bake & Bond along the ridges of the petals where the glitter will be most interesting. Then press glitter onto the glue. Lovely. Don't overdo it on this one – the glitter is an accent, not the main event.

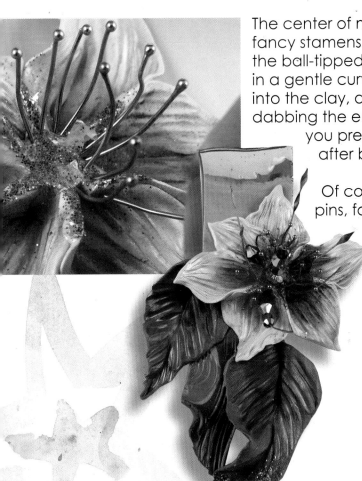

The center of many of the superstar type flowers have big, fancy stamens. Headpins make great stamens, especially the ball-tipped kind. Grab a handful of them, bend them in a gentle curve (like a Mona Lisa smile), and press them into the clay, all around the center. I also recommend dabbing the end of each pin with PolyBonder glue before you press it in. This will make sure they stay in firmly after baking.

Of course, you can also add other types of head-pins, for extra drama (I used spear-tipped head-pins). Oh, and add a crystal or two before you press the drama pins in, for extra drama! Don't worry, this flower already has glitter, so it can totally handle the glamor of crystals... it's a SUPERSTAR!

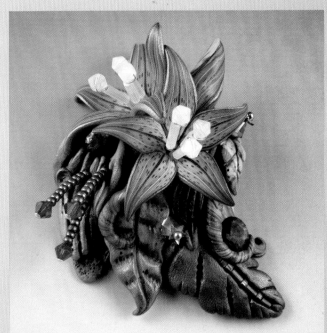

This superstar ring is the perfect accent for a toga party, don't you think?

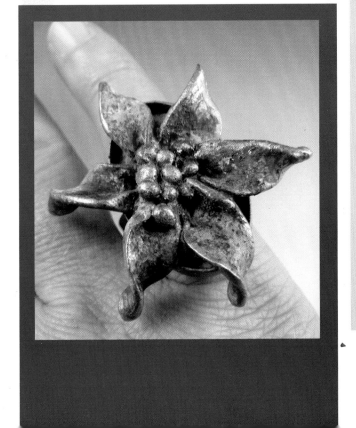

Here's another superstar flower, of the five-petal variety. This is a tiger lily (the awesome petals in this flower are canes that Lynne Ann Schwarzenberg let me use). When you use five petals to make a flower like this, shape the petals in that same football shape, then press the edges together. To make the final petals connect, just cup the petal lineup into a bit of a cone-shape so you can press the final two together.

# circle fan flower

This is a baroque marble carving... same circle fan arrangement! Timeless.

I tried to think of a more clever name for this flower type, but this is all I could come up with. If you think of a better one, just cross out the name and write in your own, I'm ok with that.

Several types of flowers are arranged in this way like hibiscus and primroses. No doubt you'll come up with other ones too. Let's make a frangipani together – one of my favorite flowers.

Start with five balls of clay, and then form them into ovals.

Flatten each. If the petals are larger (like the ones in this project), then you can flatten them over your thumb so that they are a little more cupped, like a saucer.

Lay the petals down in a curved fan shape with each petal overlapping the next. Press gently to make sure all the petals are connected together.

In order for the final petal to overlap the first petal and complete the circle, we'll need to pick it up, and form it into a cone so the petal can curl around to lay on top.

Once the positioning is correct, squeeze the cone of petals at the spot you want the flower to end (the rest of the clay can be pinched off once you've squoze!). This will cause the flower petals to open up. Nifty, huh?

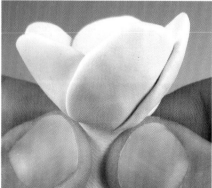

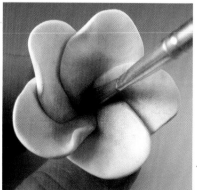

Use powder to add the color.

Slice the end of the flower straight with a cutting blade so that a little drop of liquid clay will attach it to whatever you're creating. Hey, why not make a ring with this one? It would go great with that muumuu at the next luau! Just use a drop of PolyBonder glue to attach some green clay to a ring base and then add the flower on with liquid clay. To bake it, use a wooden springy clothespin to grab the ring band and bake like that. Don't worry, the clothespin will be fine.

Slip it on. Ready for the beach?

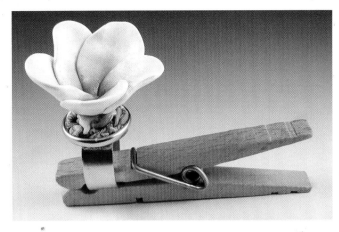

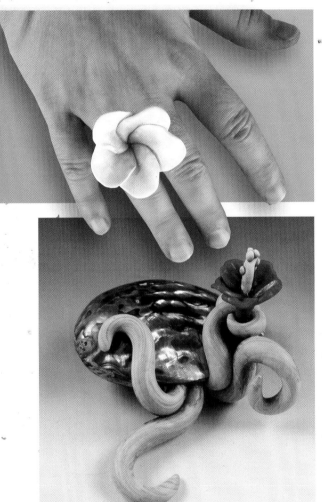

Use the same steps to make a really small frangipani – look how cute that is!

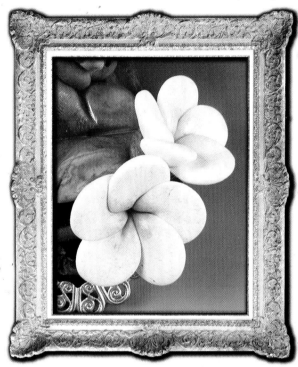

This hibiscus flower is made in the same way as the frangipani. The center stamen is a clay snake with balls of clay pressed on. Oh, this flower shows the importance of presentation. Pick the right setting for the flower, I always say, even if it's the tentacle of a romantic lagoon monster.

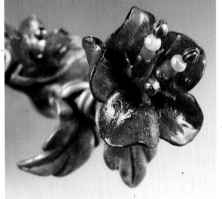

Another circle fan flower. The faux enamel effect is done after the clay is baked by adding a touch of black acrylic paint to the edges of the petals, then adding several layers of gloss glaze to the flower and sprinkling dark-colored embossing powder on while it's still wet.

49

# chorus line flowers

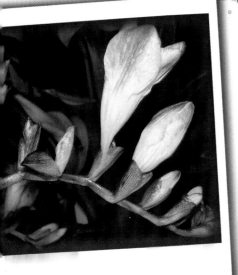

Or, you can call 'em Blooms On A Stick if you prefer. Either way, this type of flower is usually a line up of blossoms in various stages from bud to full-blown petal power! I like this type of flower. Oh, I like all the types of flowers!

The lineup of flowers needs something to be growing from – leaves and all that. I thought I'd put the whole thing on a background and make it into a brooch or a pendant. For the leaves, something long and linear is best.

To get stripes in the leaf, just gather up a clump of leafy clay, and make sure there are contrasts of color (like some whites and some deep greens to go with medium greens... that kind of thing). Flatten the wad and run it through the clay-conditioning machine just once (on the widest setting). Rip the sheet of clay up and stack them up! Cut it down the center – see all the stripes! Awesome, right?

Press the stack to the right width, cut slices and pull and pinch one end to a point. Tah dah – leaf!

Hey, how'd we get side-tracked on leaves, we did those already. Back to flowers.

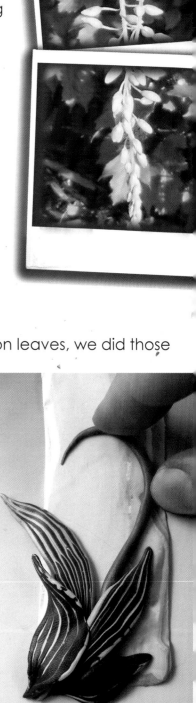

Er, uhm...one more thing about leaves, actually... we need to arrange them into a plant so the chorus line of blooms will have somewhere to kick up its petals! Make a sheet of clay for the background and shape it however you like – long and thin works well for this particular piece. Press a long snake of clay as a stem, and curve it like a hook. Add leaves.

Now we need a place for all the buds and blooms to be emerging from... I'm sure there's a scientific name for it – could you look that up and get back to me? Just roll out little ovals in size from small to teeny. Press them onto the background, along the stem – teeny at the tip, getting larger as they go along.

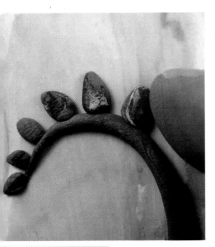

Mix up a flower color and roll out little ovals, from teeny to small. Press them onto the green things (did you ever find out what those were called?). Oh, and you may want to add a few pressed-in lines to the flower petals.

As you get to the larger blooms farther up the stem, add more petals (since those flowers are always more developed).

You can add a bit of green clay to cover up the base of the petals in the larger blooms. It just looks good that way.

Remember that once the piece is baked, you can add the pin to the back or channel for stringing, or hook for hanging – the back o' the book section has those details if you need refreshing.

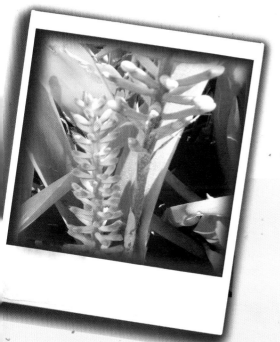

More fun with wire here. Notice the flowers? Yup, chorus line style! I like that style.

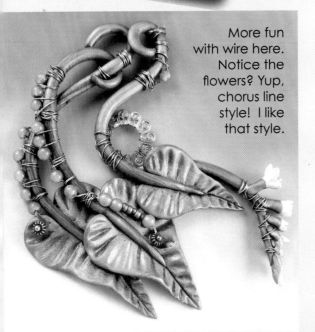

Wrapping a glass bottle with polymer is easy and makes a very wonderful art vessel when you decorate it with flora. Long snakes, pressed flat make flowing, wind-blown leaves. Wire inside the clay supports the stalk of blooms.

51

# 6 things to do with a poppy mold

I feel like making a poppy now.
Actually, first let's make the poppy and then we're going to make a mold of it, and then we're going to do stuff with the mold. Are ya with me? (There's a bit in the back about how to make molds, so if you're not already familiar with the technique after our brief dabbling with it during the round leaf project, zip on to the back and take a look for a minute. I won't say anything interesting until you get back).

And so that's how to make actual gold out of lemonade...
Oh! Whoops... You're back. No, I didn't say anything interesting.... heh heh...

Ok, back to poppies. They are lovely flowers. Which flowers aren't? Well, yeah, corpse flowers are not lovely... they're interesting-looking, but definitely not lovely (they're a thing – google it). Anyway, poppies. There are several varieties, and they're all great. Let's make a simple version of a poppy bloom, just wide open and flat. To make a simple mold, the sculpture should not have parts that curve under where the mold material can get stuck. I used a non-flower-colored clay so the color wouldn't interfere with the sculpture. I think that's a good idea when making an original – you need to see the lines with no distractions.

Make six petals – start with balls, formed into teardrops and flattened. Use a tool to press indentations into the outer edge in the same way as we did with my favorite leaf back in the leaf section.

Use a tool to make impressions in each of the indentations. Use your fingers to flatten out the tool marks a bit and make the petals look more realistic.

Flatten out a ball of clay and press the petals on it, pointy parts in. For the center of the poppy, roll out a small ball of clay and press it in the center, covering the petal ends. Now use a tool to press lines in the clay – like pizza slices. Add a scattering of little clay balls, pressed firmly all around the center piece.

Now make a mold of it! Do you know how to make a mold? Go to the back of the book for a refresher!

## 1. Partially pressed image + paint
For this you'll need some clay that has interesting color swirls in it, but is subtle. You don't want the clay to interfere with the image. I gathered up a handful of scraps (how come I always have so many scraps?) and ran it through the clay-conditioning machine until it was juuuuust right.

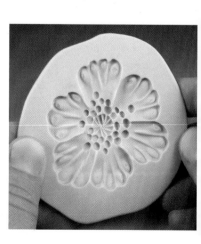

Take some of this clay blend and roll it into a ball, about the size of a big grape. Flatten it into a pillowy shape (puffy in the middle) by holding it in the palm of your hand, flattening a bit, then twisting the other hand – kinda like getting one of those child-proof bottles to open. Repeat that motion a few times to make the clay swirl interestingly.

Set that one aside for a moment and make another. How about a long hotdoggy kind of log? Flatten it just a little too.

Ok, now press these clays into the mold – mold lying on the table, clay pressed into the impression from the top. Make sure you only get a part of the flower to impress each clay shape. On the long log of clay, try pressing it just in the center. For the clay circle, how about just on one side? Or whatever. You play with them and see what makes you happy.

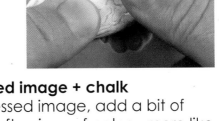

So for one of those, bake it, then use acrylic paint to antique it (details about antiquing in the back of the book).

### 2. Partially pressed image + chalk
On the other pressed image, add a bit of chalk powder. Soft swipes of color – more like impressionism, not paint-by-numbers.

### 3. Multi-color molding
You can fill a mold with more than one color of clay. So for this one, I chose a color to fill the middle and little dots, then a second color to fill each petal. Remember to use only a little bit of clay to fill each petal so you don't have a bunch of excess clay to have to trim away. Use a small blob and press it into all the parts of the mold. When you push the clay back from the edge of the mold with your finger, you'll also eliminate the need to trim after unmolding the clay!

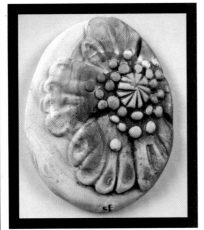

Pull the flower out gently. If you want, you can use mica powder to add some shimmer to the edge of the petals, and the center of the flower. Or not.

Whatever!

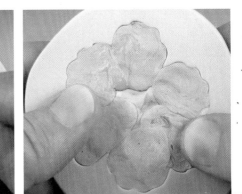

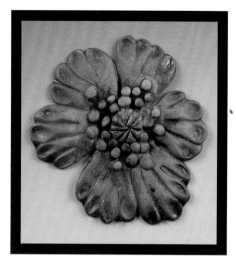

After you bake it, you can use paint to antique this one too. I think the antiquing tones down the color and adds a painterly feel, don't you?

### 4. Antique gold impression
I love gold. It's so golden. And of course, there's nothing like real gold. For this one, I suggest using a piece of 23k. gold leaf. You can use golden-colored metal leaf (or foil) instead, and it will still look good, but secretly, I'll be a little disappointed.

Roll out a small sheet of clay (any color can be great - I used the leftovers from the clay mix of the first poppy things we did since it was just laying around anyway). Trim it into an interesting shape. Next add the leaf. Gold leaf just presses right on and grabs to the clay. Clean up any extra on the edges by gently pulling it off, or folding it over the edge and onto the backside.

Press the clay sheet, gold-side down, into the mold. I didn't press it in all the way, I left some of the petals only partially impressed. After baking, use a bit more of that brown paint to antique the center lines. This will give the gold some definition and make it look aged, in a good way.

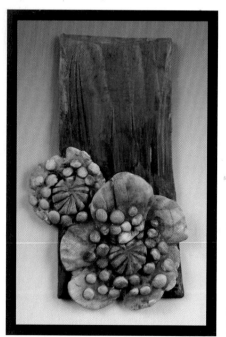

### 5. Just a Little in the Middle + paint
You can change the look of the flower by only using the center of the mold. Roll out a small ball of clay, and press it into the center of the mold, which will make the petals look very short. That changes the look of the flower of course, making it look sweet and sassy, don't you think?

Press the blooms onto a background piece if you want. You can bake the piece and then add colors. I used a thinned-down wash of acrylic paints, but you can also use alcohol inks. Adding the colors after the clay is baked, instead of making the flower out of colored clay does make it look quite different. So there's one more thing you can do with the poppy mold!

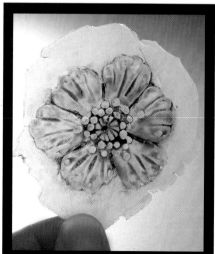

### 6. See-through + glaze
Just one more trick for now. Make a sheet of translucent clay. Press it into the mold, just like usual. Bake it. Now use the glaze with chalk mixture that we used in the Polymer Porcelain project to color the flower. Since it's a see-through glaze, the piece will remain see-through. Obviously, you'll want to use this in front of a light source, like a window, or a light. I'm sure you'll come up with something interesting.

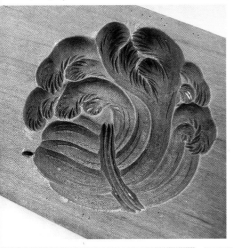

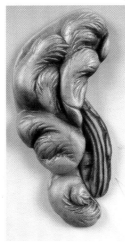

This is a kashigata of a bok choy or other vegetable clump, but of course, nobody needs to know that. Look what you can do with the shapes - get all abstract with it! Mica powder, brushed on thickly, then pulled off the surface of the clay with tape, makes the color.

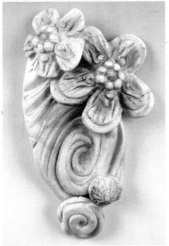

Another kashigata, and one of my favorite patterns, actually - swirls! I love swirls. It became the background for a cluster of other molds (flowers i had made and then molded just like i did with the poppy). Chalk powders give it a delicate coloring.

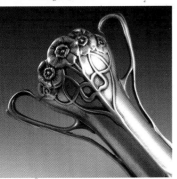

Aren't molds fun?

This is an Art Nouveau vase (isn't it cool!). A mold of the flowers can look very different when isolated from the rest of the long graceful lines of the vessel. As a pressed piece, the emphasis is on the flowers, giving it a folk-art look.

**kashigata** are Japanese carved wooden molds used to press images into special festival sweets. Using molds to impress floral designs has been around a while.

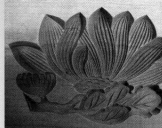

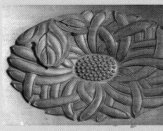

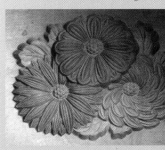

# INSPIRATION artist: *Nan Roche*
I'm inspired by her experimentation and innovation.

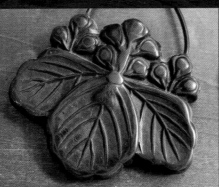

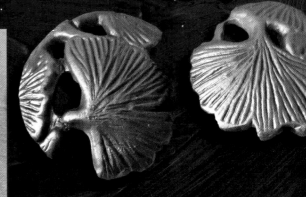

# pressed
flowers

Pressing clay into molds got me thinking about other ways of pressing clay to make something interesting. People have always pressed flowers as keepsakes, reminding them of special moments or just to hold onto the beauty of the blooms. We can do that in clay too.

You'll need a little square of glass for this. The glass from a small picture frame works great.

If you have any canes left from making petals, get them. If you don't, make a few. Reduce the canes so that they are small and delicate. Cut some slices off the canes. Press them onto the glass to make flowers from the canes. Check how they look by holding the glass so you can see the other side (this will become the front when we're done, so keep checking it!)

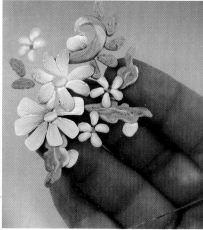

Add more flowers from different canes and intersperse little green leaves. If you're going to wear the finished piece as a brooch or pendant, keep the details small, and group them close together. If you're going to use the final piece as a wall hanging or decorative tile, make the details as large as you like.

The background clay can be all one color, or a mixture. It can be all one piece, or a crazy quilt of ripped pieces, pressed into one sheet. (I like the last way best).

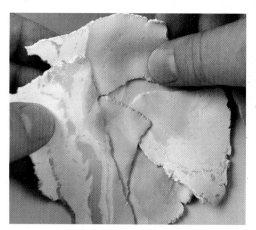

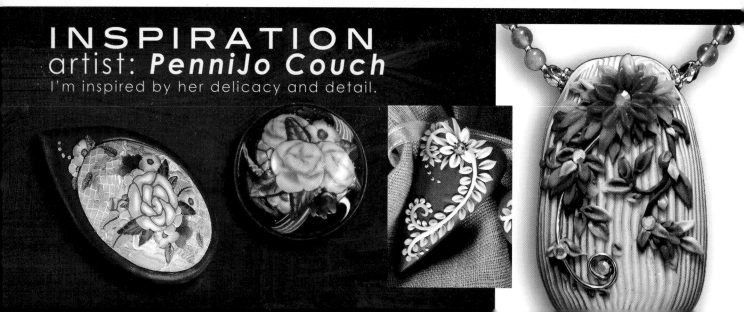

Press the background clay firmly onto all the flowers and leaves. Rub to get the bits to attach to the clay enough so that when you gently peel away the clay from the glass, all the floral pieces come away from the glass and stay on the clay sheet.

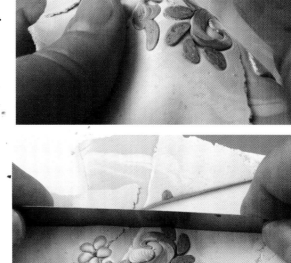

Now lay the sheet down and smooth any rough spots. With a blade, cut out a pendant (or whatever you've chosen) from the pressed flowers. Don't be afraid of slicing off some of the leaves or even some of the flowers. That usually looks best anyway. You can also cut it to fit into a bezel.

Bake it, and then add your hardware to the back, depending on what you plan to do with it.

Remember that the charm of this technique is in its loose feeling, so don't get worried if the clay gets a little smooshy – it's supposed to!

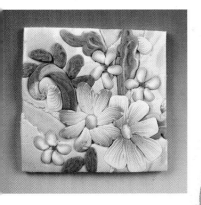

Ready for something different? Neither am I, but let's do it anyway. I feel like playing with chrysanthemum flowers next. I don't know why, I've learned not to question these things.

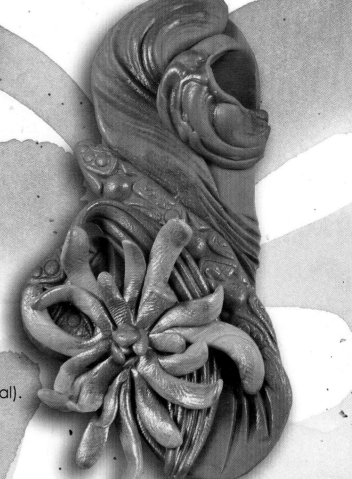

There are several ways we could create a chrysanthemum. Sculpturally, a mum is very similar in construction to the groovy flowers – just a daisy that got a little carried away with its petals. You can play with that if you want to. Just make long, thin petals and arrange them in a big circle (pressed onto that center dot of clay as usual). Then add another ring of shorter petals. Finish with an even shorter ring. Add a stone or crystal or pearl to the center, or make a bud of little petals to press into the center if you prefer.

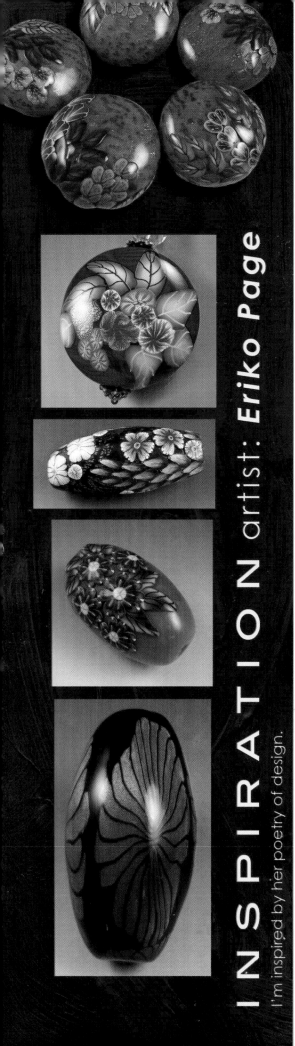

INSPIRATION artist: *Eriko Page*

I'm inspired by her poetry of design.

# chrysanthemum fan

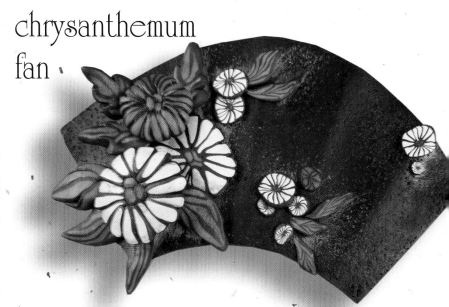

I thought we could play with a different look, one influenced by Japanese design - the patterns on kimono fabric, specifically, which tend to be simplified, stylized renditions of the subject. So, let's make a chrysanthemum cane, and then use it in a sculptural way – the best of both worlds!

You can make the cane out of any color that amuses you. You'll need a deeper and a lighter version of the color. I went with a pale pink and a deeper crimson. Make a core with the lighter color by rolling the clay into a short, thick log about as thick as a hotdog. Roll the darker color into a sheet (use the thickest setting of your clay conditioning machine). Wrap the core with the clay sheet.

Reduce this simple cane by rolling it thinner and thinner until it's about as thin as a pencil. Now use your finger to press one side flat.

No! the other side! Just kidding.

Cut the flattened cane into bits about an inch long. Press the bits together to form a half circle. Well, go ahead and make two half circles.

Set the half circles aside for a moment. Let's make another cane to use in the center. Do the wrap-around-a-core thing again, but make the core smaller (about the size of a pencil) and the wrap thinner. I used the crimson for the wrap again, but mixed a deeper pink for the center. Roll to reduce this cane to about as thin as a little pretzel stick. Cut that cane into inch-long bits, too. I used three, grouped together for the center of the flower cane. You can use more if you want to.

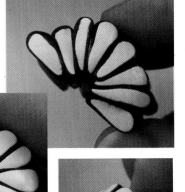

Assemble the cane by putting the center canes in between the two half-circles and gently pressing the whole thing together.

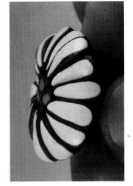

Gently squeeze the cane at one end to make the other end curve outward a bit (it'll start to look a little like a mushroom).

Chrysanthemum flowers were a favorite subject of Japanese art. Japanese art heavily influenced the Art Nouveau movement, so mums were frequently depicted by artists of that era. The Art Nouveau movement has had a great impact on artistic design ever since (it's my favorite style!).

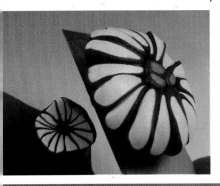

Use a blade to slice off this part of the cane and gently set that aside for now.
This is one way of using the caning method in a more sculptural way. From what's left of the cane, slice off another slice or two. To accentuate the sculptural quality, you can use a tool to press indentations between the petals.

With the little bit of cane that's left, squeeze it to reduce it even smaller and keep cutting thin slices off as it gets smaller and smaller. Set those slices aside.

On to the leaves! Make a cane just like you did for the mum petals, only use dark and light green clays this time. Repeat all the steps up to pressing the thin snake along one edge. Cut the cane in chunks and assemble them.

Two sections can be pressed together, point to point, rounded-end to rounded-end.

Add more cane sections. Press two more on the outside, and slightly down. Now two more. Press them all together to create a leaf.

Slice off a few leaf sections, then reduce the cane. Slice off a few more, then reduce it smaller... you see where I'm going here.

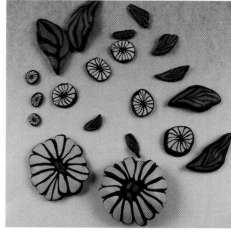

By now you should have a great selection of flowers and leaves of varying sizes.

I thought a fan-shaped base would be fun to put the pieces on, in light of our Japanese influence for this piece. Roll out a sheet of dark clay (dark blue or black would work). Use something to give the clay sheet some texture. I used a piece of large grit sandpaper. Press it all over one side of the clay. Create a fan pattern out of paper (kinda' like a big, fat rainbow) and use it to trim the fan shape from the textured clay, using a craft blade.

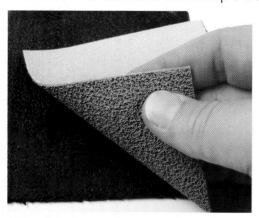  

Now use thick wire or bamboo skewers under the clay to make the fan have ridges (like a real fan would). Just slip the skewers underneath and position them, then gently push the clay down between them to emphasize the raised ridge.

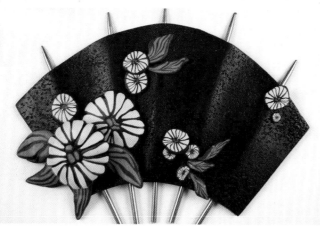

Press on the pieces! Wheeee! What fun!

Bake and add an antiquing of acrylic paint if you want (I added blue paint on the fan part – I think it looked good, and I used brown on some flowers).

Ok, I have a confession to make. While you weren't looking, I made another chrysanthemum fan from a deeper pink and added a couple slices to the arrangement because I thought it would look good. You can do that too, if ya want.

This is a larger piece, and so it could be a little too big to wear (although you can make it smaller and then it would be perfect!). So once it's all done and baked, you can go back and add hooks to the back and rebake (you know how, and it's in the back of the book if you need a reminder). You could also skip the hooks, and instead display it in a little easel. Or attach it to your chest like a breastplate and it will probably stop bullets and thrown knives, if you are a secret agent. Of course with this as a breastplate, you probably won't be a secret agent for long.

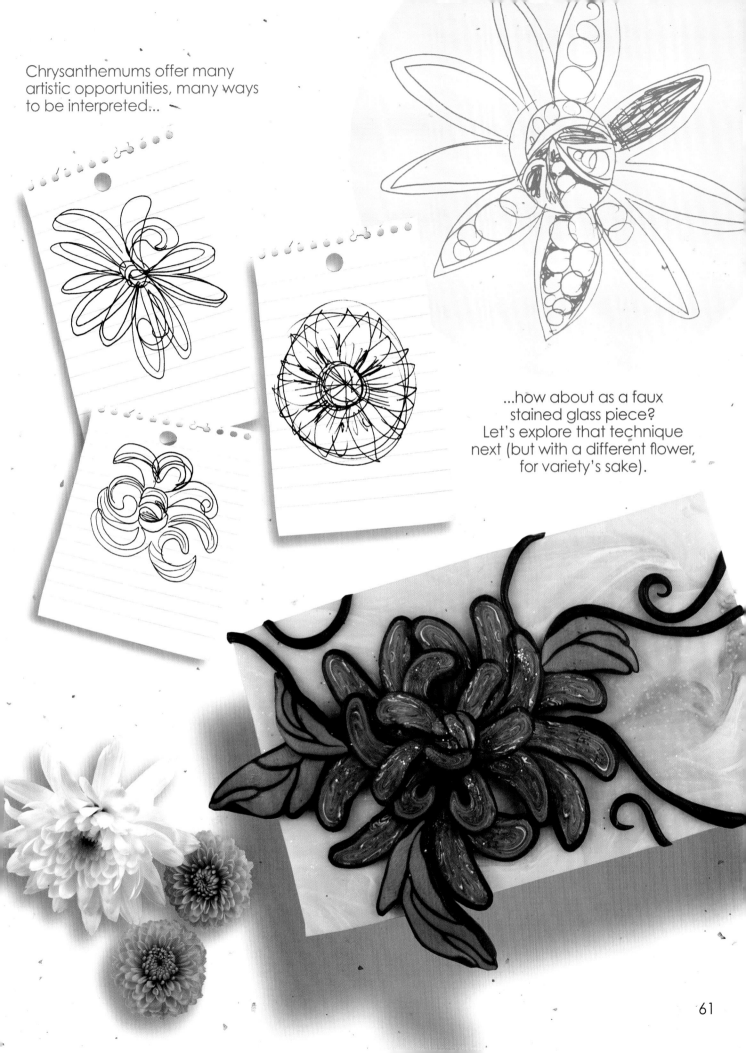

Chrysanthemums offer many
artistic opportunities, many ways
to be interpreted...

...how about as a faux
stained glass piece?
Let's explore that technique
next (but with a different flower,
for variety's sake).

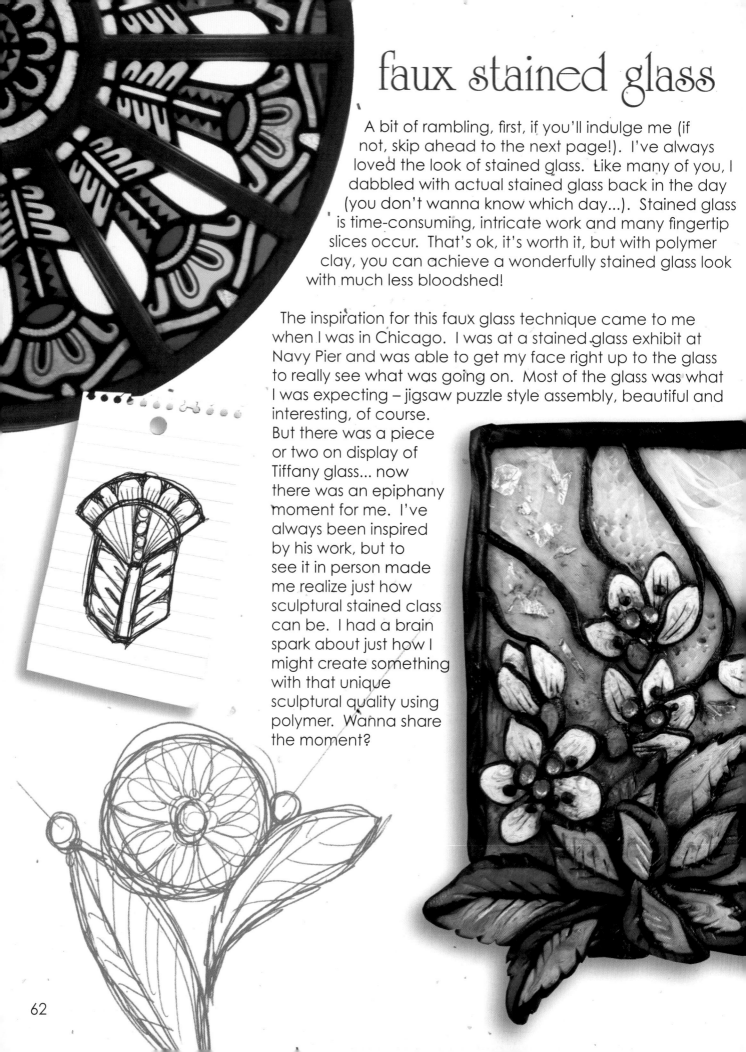

# faux stained glass

A bit of rambling, first, if you'll indulge me (if not, skip ahead to the next page!). I've always loved the look of stained glass. Like many of you, I dabbled with actual stained glass back in the day (you don't wanna know which day...). Stained glass is time-consuming, intricate work and many fingertip slices occur. That's ok, it's worth it, but with polymer clay, you can achieve a wonderfully stained glass look with much less bloodshed!

The inspiration for this faux glass technique came to me when I was in Chicago. I was at a stained glass exhibit at Navy Pier and was able to get my face right up to the glass to really see what was going on. Most of the glass was what I was expecting – jigsaw puzzle style assembly, beautiful and interesting, of course. But there was a piece or two on display of Tiffany glass... now there was an epiphany moment for me. I've always been inspired by his work, but to see it in person made me realize just how sculptural stained class can be. I had a brain spark about just how I might create something with that unique sculptural quality using polymer. Wanna share the moment?

If you've ever been inside an old, dark, stone church and seen a stained glass window with the light glowing through it, you know how magical stained glass can truly be. We'll never be able to capture that with polymer, but we can come close.

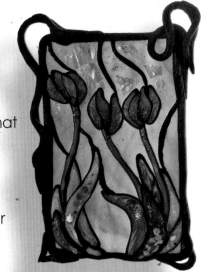

You can use this stained glass technique to make a hanging piece – let it catch the sun in a window, or other light source.

Or you can create a pendant to wear. Obviously, unless your chest lights up like Iron Man, your pendant doesn't need to be especially see-through. A window piece would look better if it is as transparent as possible, of course. The trick to making the piece see-through is to use only a small amount of color clay and a much larger proportion of translucent clay. As we wander together through the steps, just keep that in mind and adjust your color mixes accordingly.

Condition some translucent clay. We'll use it for everything. First thing to create is a color blend for the background. All the leaves and flowers will be laid on top of the background. You'll want about a quarter of a package of translucent clay (or maybe just a bit less). To that add a smidgen of white clay (which will add some of the distinctive opaque swirls so prevalent in stained glass), and a few teensy bits of color (I used blue, fuchsia and violet).

Flatten that wad and run it once through the clay-conditioning machine. Now use your fingers to rip, stack and flatten several times to spread the color while creating layers.

Once you've got a nice bunch of strata going on, flatten the whole thing with your fingers, then roll it into a tight log, like a scroll.

Now twist it as if you were ringing out a wet dishrag. As you twist, push the log together to make it short and fat (instead of pulling, which will make it long and thin).

Use a cutting blade to slice the log in half, lengthwise. Open up the sliced log and press the halves together so that the cut part is visible, like mirror images of each other.

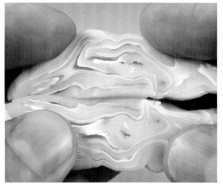

Flatten that with your fingers a bit, and run it through the clay-conditioning machine (set the machine at about the third or fourth notch from the widest setting). Fold the resulting strip so that the prettiest part is visible and run it through again. This will start making overlapping clay layers (which looks more interesting and glass-like), make the strips more subtle.

Once you like the look (don't overblend it!), tighten the machine and run the sheet through once more to make it thinner (set it to about the third or fourth widest setting). Don't fold it again. Now cut the sheet into the background shape you want. It can be rectangular, square, round or weird.

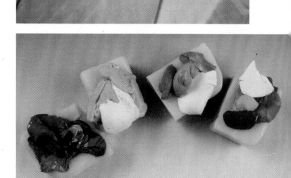

Wonderful! Set that aside for now.

Ok, so all the leaves and flowers are created from simple canes (don't worry – they are really, really simple!). I thought we'd use tulips as the design for this one since they're cool flowers...are you ok with that? Good, so that means we'll need to make two canes for the tulip flowers (similar colors or a darker and lighter version of one color) and two different greens (but ones that look nice together) for the tulip leaves.

Each color blend should be about an eighth of a package of translucent clay with smidgens of color.

Do the rip-and-stack thing to each clay clump to blend the colors together. Don't over rip-stack!

If you cut the clump open to see how the blending is coming along, it should still have streaks of color visible, like this:

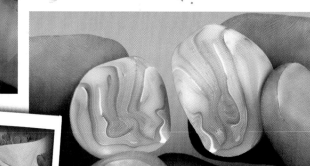

Once you've mixed up all the clumps, roll each into a log and flatten the ends (so they look like marshmallows, kinda).

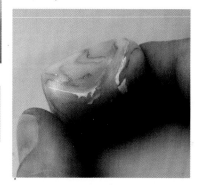

for this project,
we'll use tulips as the bloom

6

Now roll out some black clay into a thin sheet (set the machine at about the fourth notch from the widest setting). Lay a plug onto the black clay. Use a blade to cut the clay straight along the sides of the plug, leaving a little extra clay outside the edge. Cut the clay straight along the top. Wrap the black clay around the plug.

Let the top edge of the clay touch the sheet to mark the spot where you should cut the clay to allow both ends of the sheet to touch each other where they meet, but not overlap.

Roll the black-wrapped log in your hands to make sure both plug and sheet are firmly connected together. Repeat for each of the color logs.

Ok, so now here's the dealio. We will shape and manipulate each of these canes to create long leaves, short leaves and flower petals. Then we'll cut slices from the canes and use them to create the design. This way each "glass" shape is already surrounded with the "leading" just as it would be if this were real stained glass. Only easier, of course. And smaller.

The first thing I usually make are the leaves. Take one of the green plugs and pinch it to make a leaf shape – pointy on both sides and wider in the middle.

Cut a slice from the shaped cane, about as thin as a dime coin.

You can repeat the process with the other green cane too. Now shape the slices – a little curve or curl or wave – and press them onto the background. It's ok if the slices go outside the borders of the background a little bit, I think that makes the design look more interesting. You can make leaves all along the bottom, or clustered on one side, or whatever! You're the gardener!

Once the leaves are in place, we'll add a few stems and then the flowers on top of them. You can use a long, thin snake of clay for a stem, but I think that's kinda' boring. Instead take one of the leaf canes and keep shaping it flatter and flatter into a pancake... well, actually more like a tortilla.

Cut a thin slice off that; press one end into the leaves and curve it up into the background. Use your tool to cut it off at the spot you want the flower to be. Make several stems and position them.

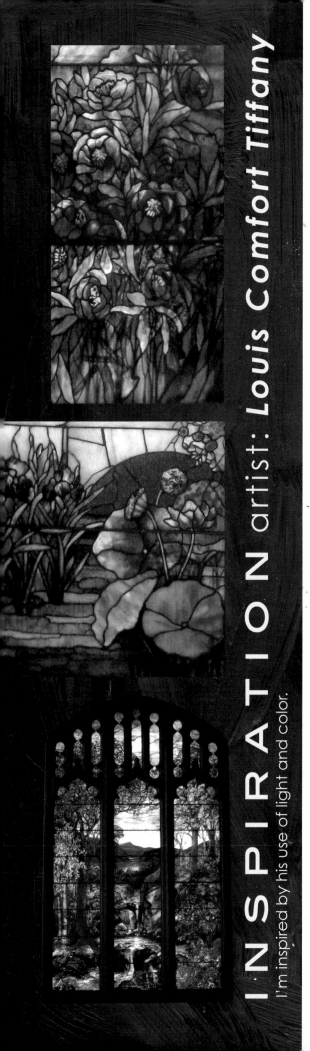

Oh, and if you want some shorter leaves, just reduce the size of one of your leaf canes by squeezing and gently pulling. Re-form it into a leaf if you need to and cut and add smaller foliage to your design. Sometimes a smaller leaf can hide the end of a stem nicely.

So far, so good – let's add blooms.

For tulips, the petal shapes are easy. Just take one of the flower-color canes and roll it smaller. It's easier if you cut the cane shorter as you reduce it – you don't need a lot, anyway! Once the cane is thin enough (depending on how big all your leaves and stuff are), shape the cane into a narrow teardrop with one end rounder and the other pinched to a point. I made both of my flower-color canes into this shape so I could have multicolored petals.

Cut slices of the canes and arrange them into the tulip blooms. The tulips are arranged in much the same way as the individual petals are – fatter and rounded at the bottom and pointy at the top. Some can be tightly closed, some can be opening... just have fun with it!

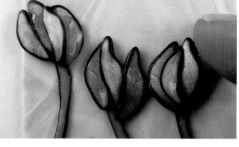

Once you're happy with the design, let's add the details that make it really feel like a stained glass piece. Start with a border all around. I just roll out some black clay into a snake and press it firmly all around the sides. Push the snake onto the background piece to make sure it attaches well. You can use lots of little bits, or one long piece... whatever!

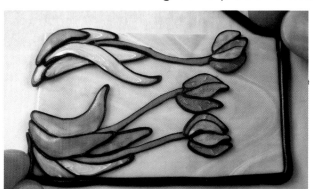

Usually I use more snakes of clay to create loops on the top so there will be a way to hang it. Make them fun, make them decorative, or make them simple. You can add them just to the top or corners, or run the extra clay all down the side too.

Real stained glass has little black lines running all through the design. These lines are the metal that wraps around each piece of glass and are soldered together. To mimic these, all we need to do is roll out very thin snakes of black clay and press them onto the background from various parts of the design out to the border. Easy peasy. I usually try to make those strands look awesome by making them flow from the design and add to the overall look of the piece. So you should definitely go for an awesome look too when you add yours.

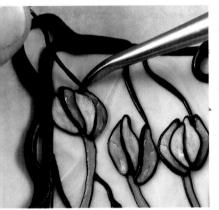

After all that stuff is done, you can use a tool to press or stroke some texture lines onto all the surfaces of the black strands and borders. Or not. It's good either way.

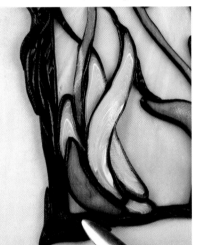

All that's left are some sparkly bits. It's fun to add some glittery or shimmery accents to add more drama. Stained glass can handle drama. I find that little shimmery flakes of "faux snow" (mylar shards), vintage glass shards and all shapes and sizes of glitters are all excellent things to add as accents to your stained glass piece. I definitely recommend that you rub on a thin smear of Bake&Bond first to help glue the pieces permanently, then press on your flakes and glitters. In order not to obscure all that work you did making the "glass" clay mixes interesting and translucent, try not to go overboard with the glitters. They are accents, not coverings! You can use your fingertip, or a tool tip to place the accents accurately. Remember that any glitter that wanders off where it doesn't belong can be lifted off with a bit of clear tape.

Isn't it amazing how dramatic that little bit of glitzy glam can make the piece look?

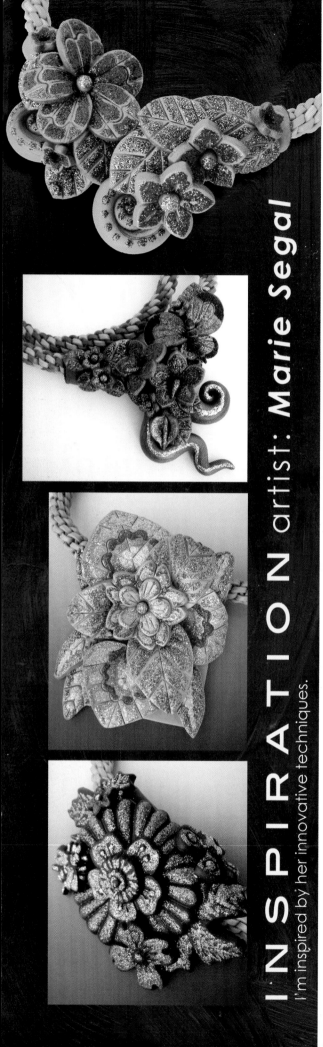

glitterglitterglitterglitterglitterglitterglitterglitterglitter

Glitter is often thought of as a craft material with no place in "art". Yeah, right. Where's the line between craft and art anyway? Where does one stop and the other start? That seems like a lengthy discussion... let's talk about that someday, but not today. Back to glitter. What's up with glitter anyway? Why do we artsy (or crafty) folks like it so much? I don't know, but I do know that the last time I bought glitter it took a big box to hold it all, so whatever it is about the stuff, it's a potent material. And of course, once you contract glitteritis, you never really recover.

Bake the piece for the full time (see the back o' the book for a baking refresher if you need it). I also suggest baking on a tile to insure the stained glass piece stays flat. Once it's done and cooled, add liquid clay to the back side of the hanging loops and

press on some fresh clay to match the front. This will reinforce the loops to add strength. Bake again for just 20-25 minutes to fuse the new clay to the piece.

So what do you think? Isn't this such a fun, easy and delightful technique? Well, I'm glad you think so, because I'd like to explore it a bit more with you, since there are other things we can do with the faux stained glass look.

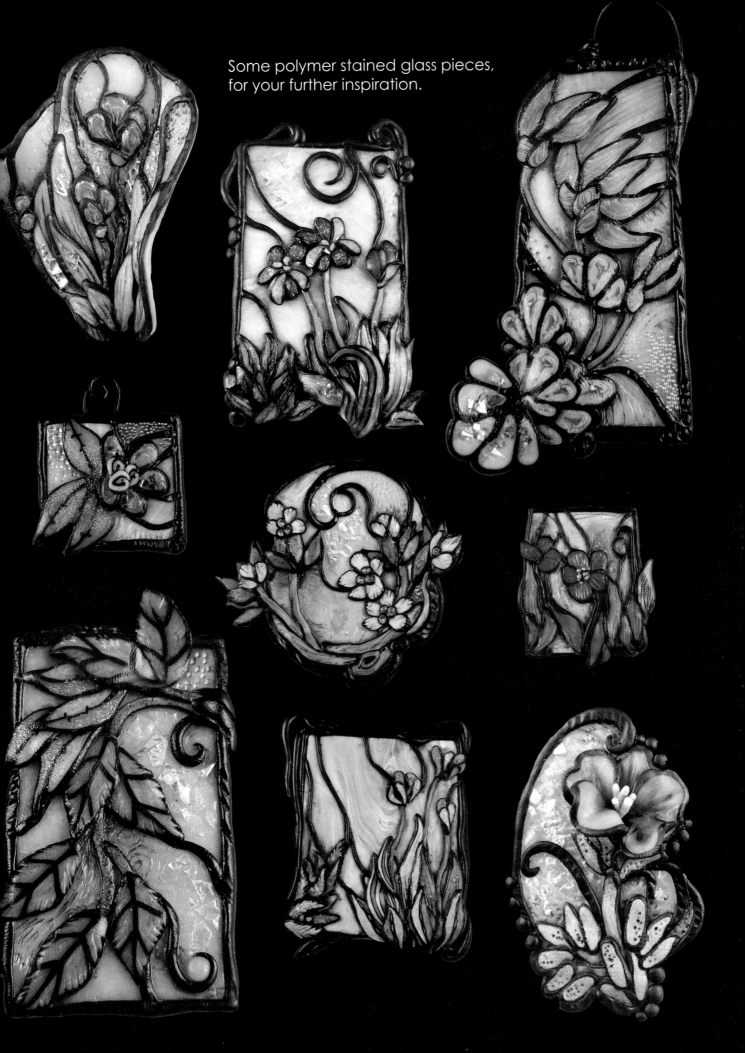

Some polymer stained glass pieces,
for your further inspiration.

You can use all the steps we just went through to create a tube bead. Interested? Start by making a background. It doesn't need to be very large. In fact, once you make the clay blend and roll it into a sheet, go ahead and cut it to size. To do this you need to get the tube that you'll roll the clay around. I used a glass test tube cuz they're cheap, go into the oven and are just a perfect size. You can use a rolled up bit of card stock too (tape it into its rolled shape, the tape can go into the oven no problemo). Cut the background to the width you'd like it to be and approximately long enough to wrap around.

Now press the black snakes of clay onto the two outside edges to create the border. Wrap the bordered background clay around the tube and cut the length so that the two edges touch. A layer of 'Kato RepelGel' rubbed onto the tube first will help it slip off easier after baking.

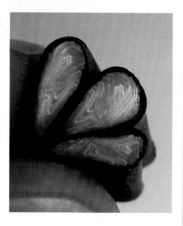

Press the edges together and smooth the join.

Now press on stained glass cane slices! I suggest you make one of the leaf canes small and press slices of that all around. Make a flower petal small too, cut three small pieces (less than an inch each) and stack them on top of each other with points together. Slices of that make a nifty flowery look.

Use little snakes of clay to curl around the tube in order to create the stems/vines that leaves and flowers connect to.

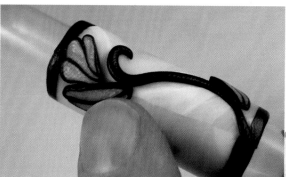

Add some glitter if you want to. Use a tool to press decorative indentations into the border if that amuses you!

Bake it (lay it in a little nest of toilet paper so that no part of the bead gets a flattened or shiny spot. After the bead is cool, you can twist it off the tube (or break the test tube and remove it that way if you prefer).

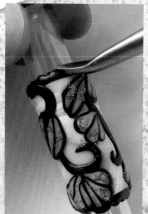

String it up and wear it! Hey, figure out some way to get an LED in there and you can glow in true stained glass fashion! (Let me know if you do, I wanna see it!)

So, we've created the look of stained glass on a background piece, what about using the technique on a freeform piece? Yup, the technique can work very well for this look too.

The trick is to create a design that is stable – leaves are clustered together, or connect to other areas (like the blossom) which makes the piece strong enough not to need additional reinforcement.

The leaves can be the same – larger canes, shaped into longer leafy shapes and several segments stacked together to make a larger, striped leaf grouping.

There is another style of leaf that's fun to make. Take one of the leaf canes and press it against the work surface to make it into a half-circle shape (like a hamburger bun). Cut the cane in half. Take another color cane (in this example I used the same orangey color that I plan to use for the petals) and roll some of it very thin. Slice this cane into three pieces, each as long as the half-circle leaf pieces. Lay them all one next to the other on the flat side of one of the canes. Place the other half-circle cane on top – like a hamburger with hotdogs inside (hmmm, that would taste pretty good... but might be hard to eat, now that I think about it).

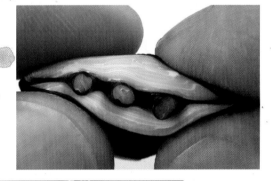

Press the canes together to remove any space between the pieces. This is the same sort of thing that we talked about way back in the beginning, in the leaf-making section, remember?

Stem, you know how to do that. The flower, easy, too. Petals are teardrops (I pressed the middle of the petal in with a tool to make it look more nifty-er!). Position the petals together into a circle. Add something fun in the center. I made a little circle of round canes, but you can experiment and see what you come up with.

Looks good, huh? String it up with a ribbon once it's baked, if you wanna.

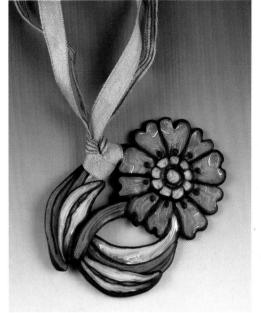

After you've made some lovely faux stained glass stuff, you'll have a little pile of scraps. Guess what... you can make something from them too! (something good, I mean).

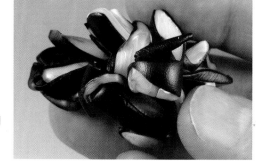

A big thanks to Alice Stroppel for sharing this layering technique with the polymer world!

Roll out some black clay into a sheet (use the widest setting on the clay conditioning machine). Cut it into strips about an inch or more wide. Rip or cut those strips into lengths about two to three inches long. Sprinkle some of the scraps on one of the strips, lay another strip on top. More scrap sprinkles. Another layer – like making lasagna! Keep going until you run out of scraps, and then finish with a strip of black clay.

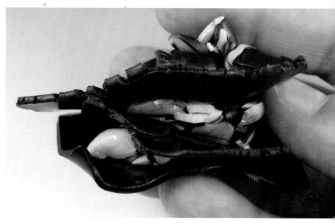

Use your hands or a roller to press the air spaces out of the layers and make the whole stack more compact. Cut the stack in half with a cutting blade (it doesn't matter where you cut or how – lengthwise, through the middle – whatever). There are lots of things you can do with this cane, but of course, I'm interested in doing something flowery with them. Are ya with me?

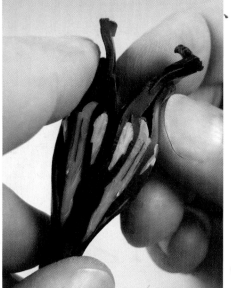

Press two cut halves together to make a mirrored image. Kinda' looks flowery already, huh?

Cut a slice or two from that mirrored image cane. As you cut, each slice will be different because of the assortment of little scrap bits in there. Cut as many slices as you like. Form them into plant-like shapes by bending and curving. Colored parts are like the buds and the green areas are leafy bits, don't you think?

Ok, so now roll out a sheet of black clay and arrange the slices into an organic composition by pressing the slices onto the sheet. Cut the clay around the cane slices, leaving a border.

Looks great right? Add a clay channel on the back for stringing, or a pin backing if you prefer a brooch.

So goof around with this a bit, I think it's worth some playtime.

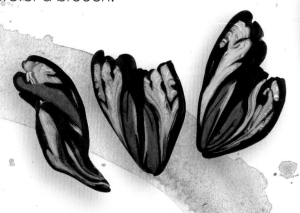

I'm still not over the stained glass thing. I've got one more trick to show you.

In the world of actual stained glass, one of the techniques is to create the design as a composition of shapes with the details painted on (with glaze and then fired and all that glass stuff, details not important here). But that technique is very adaptable to polymer.

Start by sketching out your idea. I decided to use another of my favorite flowers as inspiration – a Morning Glory.

Of course, being able to draw is a big asset to this step. If that isn't your strong point, start Googling images of flowers and pictures of flowers. Don't trace someone else's art, of course, but look at the pictures you like. What are their similarities? Usually that will show you your own design preferences. Use that information to start sketching.

If you're having any trouble coming up with an idea, do what I always do in this situation. Put on your **Imaginationing Cap**, and have some lovely chocolates and a cuppa **Creativity Elixir**. In no time at all, you'll come up with a great idea, I guarantee it!

Usually a blossom, a bud or two and a couple leaves will make a nice design composition. Go with large shapes. Trace them onto paper and cut each shape out.

Condition some translucent clay and roll it out into a sheet (the widest or second widest setting is a good one to use for this). Lay your design shapes onto the clay sheet and cut around them. Bake the shapes for about 20-25 minutes. I suggest you bake them on a tile to keep them flat.

Once the shapes are cooled, use a bit of very fine sandpaper to add some 'tooth' to the surface of the clay ('tooth' is a thing – look it up!) Now do you have some colored pencils? Well, go get 'em! (Oh, and the softer the lead in the colored pencils, the better!)

Use your colored pencils to draw in details on the leaves and flowers. Refer to your flower photos to help get everything correct.

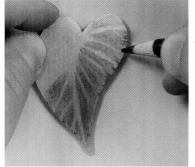

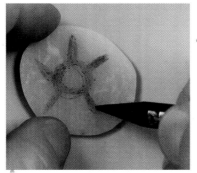

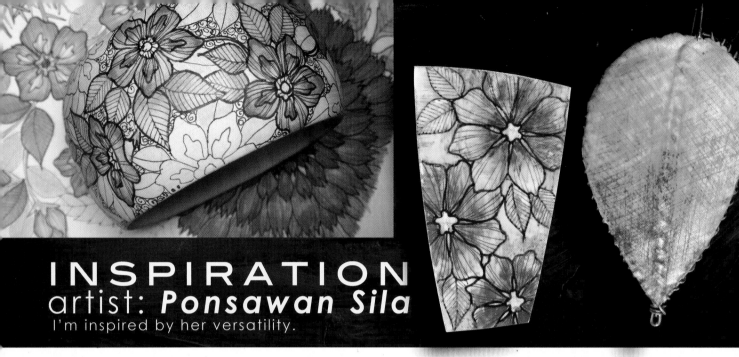

# INSPIRATION
## artist: *Ponsawan Sila*
I'm inspired by her versatility.

Once all the pieces are done, I suggest you coat the pencil to protect it from being rubbed off or smudged. Use a clear glaze that's compatible with polymer and can handle a trip back into the oven. (The back of the book will guide you with this info).

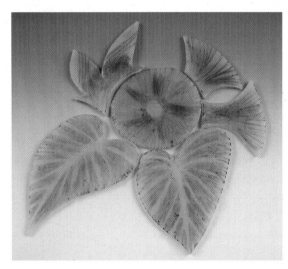

This next bit really mimics what would happen if we were working in actual glass. Glass would be wrapped in strips of glue-coated copper and then the pieces soldered together. Work. Much easier in polymer. Roll out thin sheets of black clay, cut it into narrow strips (about twice as thick as the width of the edge of the colored polymer shapes). Next add a thin coating of liquid clay to the edge of one shape.

Wrap the shape with the black clay strip and press it on firmly. Then use your fingers to pinch the clay around the front and the back, encasing the shape. A needle tool will help press the clay into any tight spots.

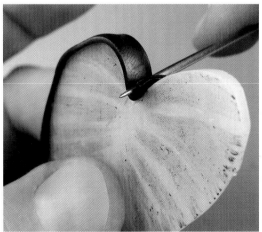

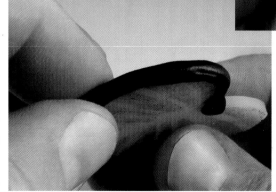

Once you've repeated this with all the shapes, you can press them back together into their design again. First add a touch of liquid clay at each of the connection points to help the clay attach better. Also a drop of liquid clay on top of each connection point will allow you to press small balls/snakes of clay on the top. This will help with additional strengthening as well as adding a nice little "soldering" look-alike touch.

You can add some loops of clay to hang the piece from.

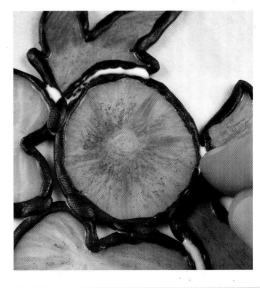

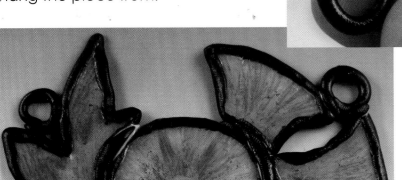

Bake again to fuse everything together.

Ok, so it's fine as is, but if you'd like to make the black look a bit more like darkened metal (which is the part of a stained glass piece that this is mimicking), then you can rub the black clay with a bit of metal rub or add some metal coating/darkening agent.

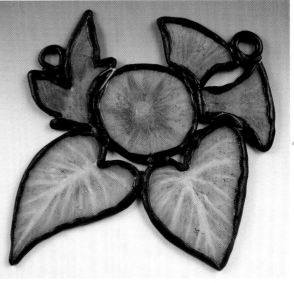

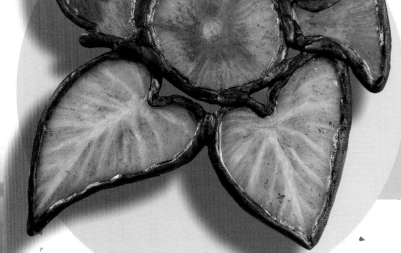

Here's what that looks like. Pretty cool, huh? We're getting to the metal coating part in a few pages, so you can skip ahead if you want to and see what that's all about. Just thought you'd want to know.

Ok, I'm done with stained glass stuff for now. It's great fun, but I guess it's time to move on!

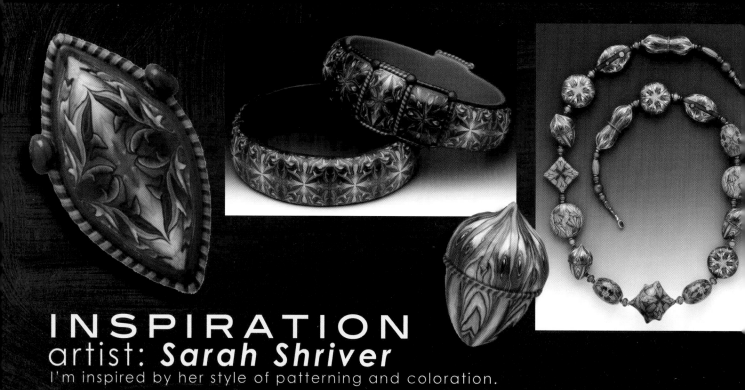

# INSPIRATION
## artist: *Sarah Shriver*
I'm inspired by her style of patterning and coloration.

This seems as good a place as any to take one last long, lingering look at caning. By now you know how useful a technique it is, and how many ways it can be adapted. So before we wander away from caning, and continue sculpting, let's take a look at a few artists who really know what they are doing!

*Alice Stroppel*

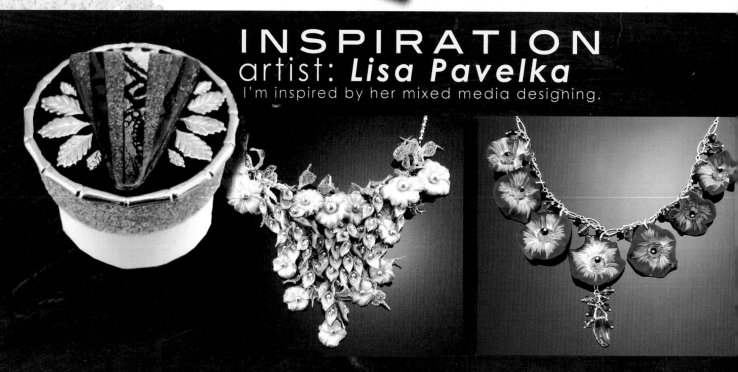

# INSPIRATION
## artist: *Lisa Pavelka*
I'm inspired by her mixed media designing.

# INSPIRATION
artist: *Lynne Anne Schwarzenberg*
I'm inspired by her intricacy and beauty of design.

Joan
Israel

Iris
Mishly

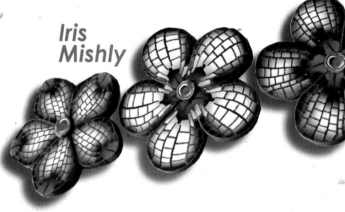

Ellen
Prophater

# INSPIRATION
artist: *Jana Roberts Benzon*
I'm inspired by her delicious complexity.

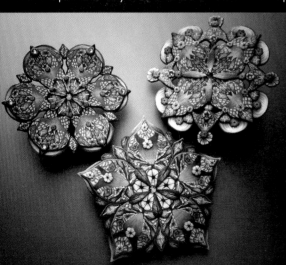

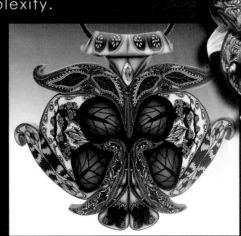

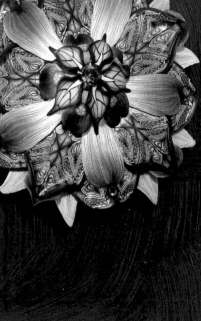

# sgraffito

"Sgraffito" means "scratch" so you know this is going to be an easy trick. The technique has been used to decorate the walls of buildings by scraping a pattern into a surface coating to reveal a different color underneath. It has been used on walls in Europe since classical times! The same technique has been used on pottery decoration as well, since forever! You might remember using it as a kid when you scraped through black paint to uncover the brightly crayoned surface beneath. Remember? Everyone did it in grade school. I think you had to or you weren't allowed to pass second grade.

Shall we adapt the technique to clay? First make a thick sheet of dark clay and cut it into the shape you'd like. Next roll out a very thin piece of a light clay and press the dark clay onto the light clay and cut to the same shape. Press the two together.

As an alternative, you can bake the thick dark piece of clay, coat it with a very thin layer of liquid clay, then apply the thin light clay sheet. Each version makes the scratching part of the technique act a little differently. You can experiment a bit and see which one you like better.

## Now scratch!!!

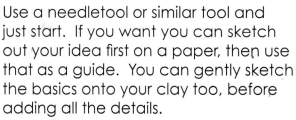

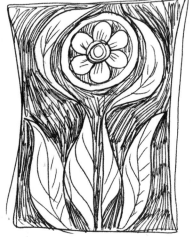

Use a needletool or similar tool and just start. If you want you can sketch out your idea first on a paper, then use that as a guide. You can gently sketch the basics onto your clay too, before adding all the details.

Keep scratching the design into the surface clay until you like what you see. You may notice lots of little gunky bits from the scratching. Don't worry about them just yet.

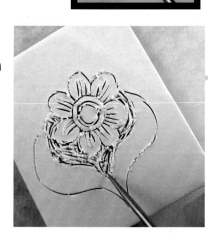

Bake it. Now we can worry about the gunky bits. Well, not really worry. Get rid of them. Just use some fine sandpaper and sand them right off. Easy.

I like how this looks, like a gritty pen&ink drawing. Different, huh?

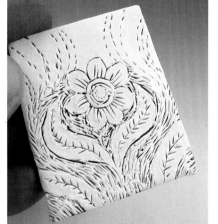
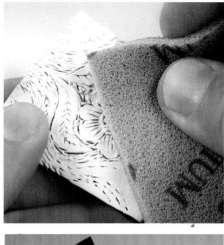

Of course this piece is fine just like it is. You can wire wrap it, use it in a bead embroidery piece, add holes and string it to whatever. Sometimes encasing it in a setting is good too. You can make the setting very clean and straight as a contrast to the scratchiness of the design, or continue the rough look. Here are some thoughts on how to add a more rough setting.

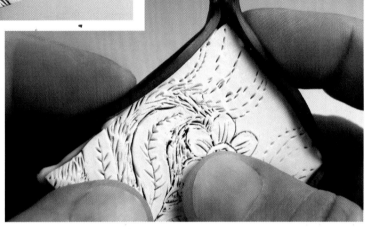

I like adding the setting after the piece is baked so that none of the scratching gets mushy. Just add liquid clay to the back and lay the piece on a sheet of thin clay. Cut around the piece to leave a thin border all around.

Cut the extra clay from the edges and smooth everything around. To make a stringing channel, just roll clay around a thick piece of wire (make sure the wire is uncoated or it'll become a permanent part of the piece!) Cut off the excess clay so you now have a tube of clay with a metal wire inside.

Use liquid clay to attach the channel clay to the top of the border. Press firmly. Use your tool to make some texture lines to the border clay and to drag bits of the border onto the surface of the sgraffito, if you want to.

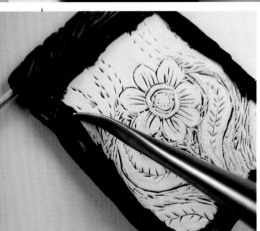

Bake again to fuse all the pieces. Pull out the wire and string it up!

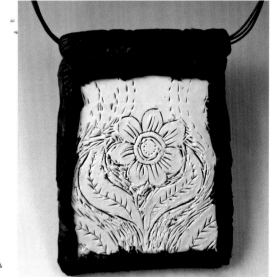

# Oooh La La
# Orchid

# Orchids really are spectacular flowers.

These are flatback crystals with a hotfix glue backing, which means we can press them into the polymer and the heat-activated glue will adhere itself during the baking. Sooooo easy.

We'll use crystals to make this orchid extra spectacular.

I have lots of orchid plants in my studio for constant inspiration because I just love them! The blooms last for months and I can mostly ignore them, which is what ends up happening most of the time.

Orchids are also very showy flowers, and associated with dressing up and looking glamorous, as anyone who's ever gotten a corsage plainly knows. So in addition to exploring some sculptural details in creating orchid flowers, let's also explore another embellishment material – crystals. Crystals are also glamorous and showy, so the two go together well, don't you think?

There are several kinds of orchids, they're all shaped similarly. This one is going to be like a cattleya orchid – the showy corsage variety.

You can make it out of any color, of course. Pick something that goes with the crystals that you have.

Orchids have six petals. Five of those will be about the same size, so roll out five balls of clay, about the size of hazelnuts (yeah, I don't really know how big those really are either).

Shape three of them into pointy ovals – round in the middle and pointy at each end.

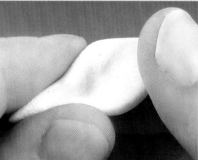

Flatten each of the three petals and pinch one end, to add a bit of a shallow bowl to each.

For the other two balls, teardrops will be the better shape. Press them flat too, and especially flatten the rounded end. Add some irregularity to that end by really pinching firmly.

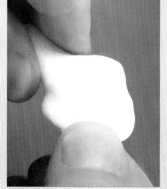

For the final petal, roll out a larger ball, turn it into a teardrop and flatten it. Pinch the rounded end flat too. For this petal, and the other two teardrop ones, use a tool to add more exaggerated ruffley scallops,

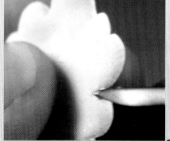

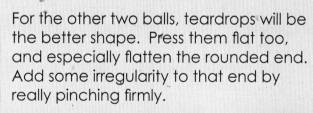

81

Now flatten the rest of the petal just a bit and roll it to make it a bit more like a tube at the non-ruffley end!

Lay all the petals out to make sure everything is going to look good together. Adjust length and thickness as needed.

To assemble, first make a couple leaves. Orchid leaves look like tongues – just flat ovals of green clay.

Assemble the flower by pressing all the petals together on top of the leaves. The pointy parts of the petals should all touch each other in the center. Press the top petal on last by pressing the inside of the petal against the center (instead of just laying the tip into position), then curling the petal up and over. Use a bit of toilet paper to hold the petal in position.

And now the fun part! Adding crystals! Ooooh, la la! Just press them into place. Any glass crystals will work fine. Use tweezers or a wax-tipped picker tool to pick up the crystals and use your finger or a flat tool to press them into the clay just enough to stay put. Crystals with a glue backing will take care of themselves in the oven, you may have to glue any loose crystal back in place after backing (if you use crystals with no glue backing). You can be as dramatic as you want with the crystals. Have fun.

Bake and show off!

This is a much simpler version of the same orchid, doesn't it look good as a bangle?

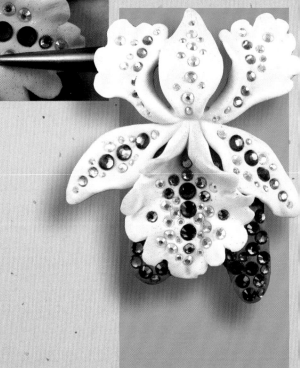

# everything's coming up ROSES!

Well, really, you didn't think I was going to forget roses, didja? They're kind of a must-do flower. There are a number of ways we could make roses. I thought we'd do a small, sweet one, a quickie rippy one, and a kinda carved stone one! You cool with that?

The 'small, sweet one' is what I would call a classic rose look - the romantic kind. You don't have to make it small, the same technique will work large too (but between you and me, it's easier to do these small since bigger ones require you to take a bit more effort in forming the petals).

Blend a nice rose color (if you want to blend it so that you have some variation in the color – lighter and darker hues – you'll have more variety in your rose).

Roll out small balls of clay and press them reeeeeeally flat between your fingers. Make some bigger than others so that the inner petals can be smaller. It's also a good idea to make the inside petals out of the lighter part of your clay blend so the center of the rose is a lighter color.

Now get a bit of the lightest part of your clay and roll out a short snake of clay. Press it flat too.

Gently roll it up, then pinch lightly on the bottom of the roll. This will keep the rose small, and give you a little handle to hold on to as you construct this flower. It's also really helpful to angle the wrap upwards so that the roll forms a shallow bowl, not a little pyramid.

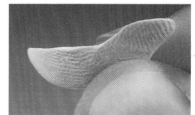

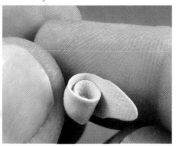

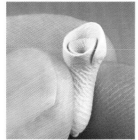

Now add petals. Start with the smaller ones, and if they are also a lighter color like the center, that's good. Press one petal in place. Press the next one on by overlapping the end of the one you just placed. Also place each petal so that it comes up a little, keeping that bowl shape. As you place the petals, keep pinching the bottom to attach the petals and let the flower open up (pinching will do that naturally).

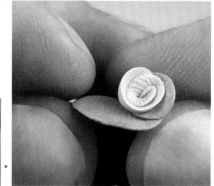

Stop adding petals after 5 or 6 or 7 petals or you'll have a cabbage. A beautiful, colorful cabbage.

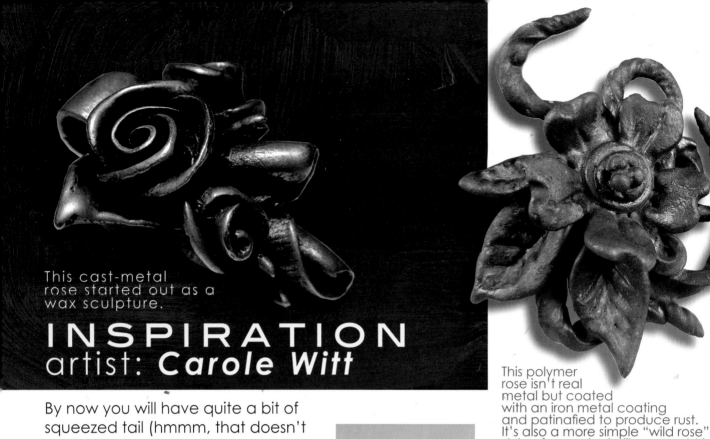

This cast-metal rose started out as a wax sculpture.

# INSPIRATION
## artist: *Carole Witt*

This polymer rose isn't real metal but coated with an iron metal coating and patinafied to produce rust. It's also a more simple "wild rose" style of rose... looks like wrought iron, doesn't it? We'll be talking about the faux metal stuff next, I promise.

By now you will have quite a bit of squeezed tail (hmmm, that doesn't sound right). Pinch off the excess or use a blade to slice it off.

Make a few more roses – a cluster looks good. Prep your ring/pendant/brooch background... wherever your flowers will live. I'm doing a ring, so I'm adding a drop of PolyBonder glue, pressing in green clay, and adding a few simple leaves (rose leaves are just the "generic" type of leaf, with a pointy tip.

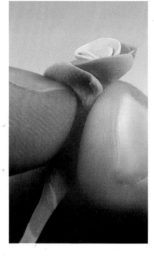

The easiest way to position the easily-mushable roses is to lay a generous blob of liquid surface on your base, pick up the rose by using the tip of a needle tool, press it into the flower, (between two petals) and position the flower in place on the liquid clay, then pull out the tool.

Don't forget to use the clothespin trick when you bake it!

Lovely little finger bouquet, huh?

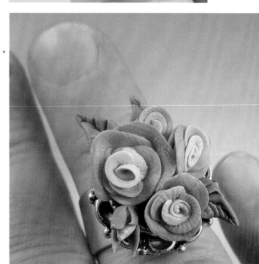

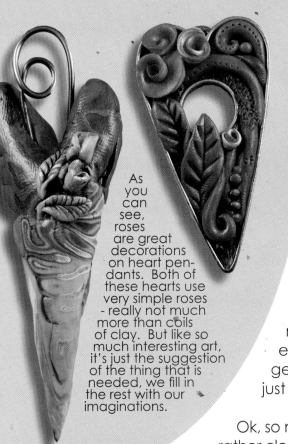

As you can see, roses are great decorations on heart pendants. Both of these hearts use very simple roses - really not much more than coils of clay. But like so much interesting art, it's just the suggestion of the thing that is needed, we fill in the rest with our imaginations.

So here's my thinking about making more than one version of a rose. The thing about art is that it's not just reproducing reality. It can be, but the real fun begins when you start tweaking. No, not that kind of tweaking. The kind of tweaking where you start changing things from **"that looks just like a rose"** to *"that is a really cool rose-ish flower"* and even, **"I don't know what that is, but I like it!"**

It helps to know what a rose really looks like first, because then the tweaks are an adjustment of reality to create something that could be real, even should be real. So that's why there are so many pictures of real flora in this book - seeing the real thing gives you a starting point. Practice and experimenting gives you direction and eventually you get really good. And of course, in the meantime, it's just fun! And you can never have too much fun.

Ok, so now, back to rose variation #2. We're still going to stick rather close to reality with this one, with just a bit more artsy.

Mix a rose-colored clay. Instead of rolling out round balls of this clay to make the petals, pull off irregular chunklets of clay and smash them very flat between your fingers.

Assemble them in the same way as the first rose – one curled in the middle, then the other petals pressed around and around, overlapping each other to create the bloom. Pinch the petals to make them open, and to give you that handy handle.

This rose will have those fun leaflets that roses sometime have, ringing around the blossom. Just roll out a thin sheet of green clay and rip it into long triangles. Rip it good!

Press those leafy shreds all around the blossom. Press them on.

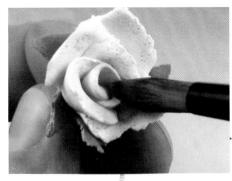

Pow! Add some powder to the center... just because you can!

Pinch the handle longer and thinner, like a stem. Pinch/cut off the excess handle/stem. Set the rose aside for a minute and look what you pinched off. Chances are there's a bud in there – do you see it? All it will take is a little bit of shaping! And maybe a few little shredded leaflets! Success!

You know what would be cool? If we wrapped the bloom and bud in something papery-looking so that it seems like it just came from the florist and was presented as a token of love or friendship or some other emotion with an interesting backstory that will become full of longing and misunderstanding and heartbreak, but then end on a really beautiful, tearful reconciliation and promise of everlasting love and the music swells and everyone sighs, but then you leave the theater into the light of day and have to go back to cleaning the house and paying the bills and driving to appointments and all that stuff where there are a lot fewer yellow rose moments than there ought to be...

Ok, so anyway, if you roll some white or ivory-colored clay through the clay-conditioning machine (set very thin) you get a very thin piece of clay that can wrap right around the roses and really feel like wrapping paper. Don't forget to add a strip of colored clay circling the middle as a ribbon.

That looks cool huh? Bake it and then add a pin back or a hanging loop (remember those technical how-tos are in the back o' the book).

So, still close to reality, but the design tells a story, makes you feel something in addition to "oh, look, roses", right?

One more. Just a step farther from reality still (but not all the way to Picasso or Salvador Dali land... although you can keep going – it's really nice there this time of year).

How about taking what we know about roses so far and pretend we were chiseling one from a slab of granite? We'd want the details to be more simple since chiseling is hard work.

Make a granite-colored blend (hint: add some embossing powder to the clay for those delightful rocky flecks). Use a roller to roll out a thick slab. Rip it into a nice rocky rectangle. (You can leave all the sides rough, or smooth some or all four – your call!) This is your stone from which your 'carving' will emerge. We'll cheat of course.

Cheating is ok in art – we're going for a "look", so you can shortcut, fake, faux or mimic to get there! For example, instead of carving a rose from the clay to try and reproduce the look of a stone carving, we'll add a sculpted one onto the base, and then add texture to make it look like it was carved. Fake reality. Creative cheating. Of course, you may first want to look at pictures of actual stone carvings to get a feel for the little telltale signs in order to better mimic them with clay.

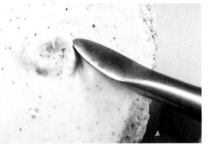

(You do know what I mean by 'cheating' right – I'm talking about that fake reality thing, not about ...aking other artists' work, and all that ethical stuff... creative fakery! Not ...ake creativity).

...ack to roses. Start the bloom with a little curl of clay in the ...enter of the "stone" slab.

...se a tool to blend it in so that it no longer looks like clay that's ...aying on the surface but like a detail that was "uncovered" in ...he carving process. Basically, use a tool to blend the edges of ...he curl while leaving little impressions behind.

...dd more snakes of clay to define additional petals. (It helps to think of it as a rose that is ...lowly emerging up from a bowl of milk so you can only see the tops of the petals as they ...ome into view. This is a typical 'bas relief' perspective – a fancypants word for this type of

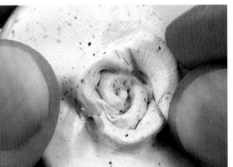

sculpting). As you add petals, keep up the blending and texturing. Pressing your tool in to make little parallel lines is a nice stone-cutting look. Throw a leaf or two into the design. Use the edge of a tool to put some serrated edges on them ...it's a rose-leaf thing.

Add some very light touches of powder (chalks would be best, not shiny micas) to add some aging to cracks and crevices.

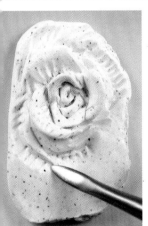

Bake as usual. Take some fine sandpaper to it if you'd like to add the look of a more worn-down stone that's been out in the elements for awhile.

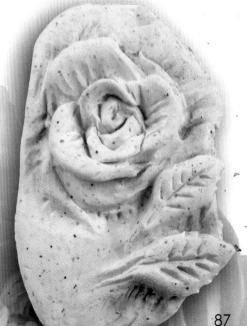

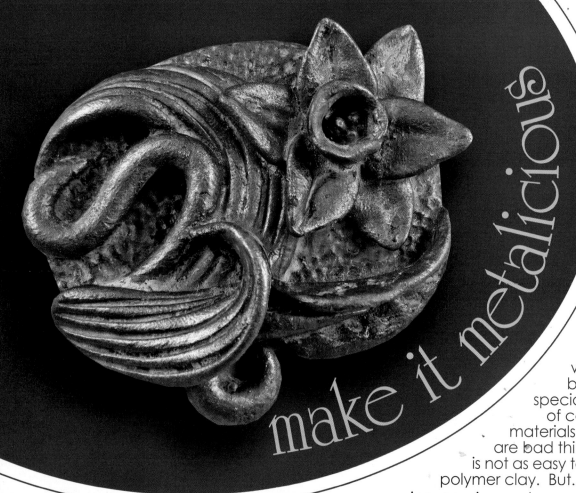

## make it metalicious

I've promised you that we'd play with faux metal ... numerous times if I recall correctly... and now it's finally time

Mmmmmm mmm I really, really really love the look of metal. Creating with metal is a whole world unto itself with so many beautiful avenues to follow... but creating with actual metals can be tricky. It can require specialized equipment, and of course, more expensive materials. Not that any of those are bad things. It's just that metal is not as easy to play with as good ol' polymer clay. But... what if you have the inexpensive and easy-to-use polymer clay to create with and then could POOF! turn it into metal? That would be superfantasticawesome, right? Well then, let's do that ... mostly. We can't actually poof clay and make it literally turn into metal (you need to be a 33-level Alchemist to do that), but we can coat the baked clay with special metal coatings and then apply patinas to age the metal shell – next best thing to the real deal.

I thought we'd make another flower together first, since we haven't done anything with narcissus yet and they're such nifty flowers. Then we can use that flower in our metal transformation. Oh, it'll also be a good excuse to play a bit with the Art Nouveau style (did I mention that it's my favorite artistic era and I just LOVE anything in that style?) So, that's a lot of stuff all at once – can you handle it? Me too.

First of all, the sculpture. As we've talked about before, the sculpture part, the way the design is composed and how you put together the details are the most important part of any creation. You can fake a lot with color and bling and accents, but if the actual sculptural part of the piece is not right, all the other added things can't fix that (they can disguise it to some degree, but it's like a tiara on a pig – interesting, but you know it ain't a princess). This is especially true when adding a faux metal coating to polymer. The lines have to be good because we're taking away a lot of the color possibilities. So usually if I know I'm going to be adding a metal coating, I create in all one color (usually something white or whatever clump of lighter-colored clay I have lying around) so that I can concentrate on the lines, and not let color distract me. Of course, another thing the metal coatings do is rescue a piece where the colors just turned out wrong, or got a little scorched in the oven – they cover right over that stuff.

So, grab some clay (and do make sure it's all mixed thoroughly, any streaks of color will be distracting as you sculpt), and make a base for the narcissus to live on. I'm anticipating creating a pendant, so I cut a sheet of clay into an oval shape. I'm into rounded shapes anyway (ovals and circles or rounded-corner rectangulars), and the oval is a very Art Nouveau shape, so it's all good.

I also put some other leaves and such on the base in preparation for the flower. Narcissus, daffodil, paperwhite – they're all cousins, and these steps will work for any variation of this type of flower you want to do (just look up some pictures and adjust your clay accordingly – longer center cup, longer or shorter petals, ruffley edges... whatever works for you). The leaves for these species are long, flattened snakes with lines running down the length – a long, skinny version of the 'road-kill' leaf!

The narcissus has six petals. Three evenly spaced ones on the bottom and then three more on top, overlapping them and filling in the spaces. Roll out six little balls of clay, form them into fat teardrops and flatten each with your fingers. Use a tool with an angle edge to press an indentation down the middle of each petal. Use your fingers to soften the tool mark.

Press the first three petals into place on the base, equally spaced.

Press the next three on top – all the rounded edges are towards the center, pointy tips out.

Narcissus have a cup-like thingy in the middle. Roll a small ball of clay and press it around the end of a tool (a needletool works really well). Form the clay so that it looks like a little shot glass, around the tool.

While you're holding the clay, spin the tool a bit to help loosen the grab. Now press the clay, still around the end of the tool, firmly into the center of the petals, and twist the tool out.

The center of this type of flower should have some stamens showing – to make those, just roll out short, fat little logs- three to five of them – and clump them together. Don't smush too much. Cut the end off one side so they'll fit into the flower's cup. Add a nice bloop of liquid clay to the center of the flower first, then pick up the stamen clump by inserting the tip of your needletool between the pieces and transferring it to the cup. Just place it into the center, the liquid clay will grab it, no need to press to attach.

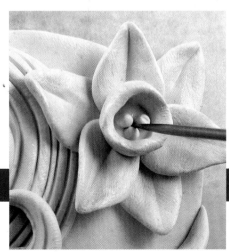

That's all there is to it! Add more of the same flowers to your design if you want to, or not, then add any details and textures to finish the piece. Bake as usual. Add any pin backing or stringing/hanging wires/channels and rebake as needed. And NOW we're ready to play with metal coatings!

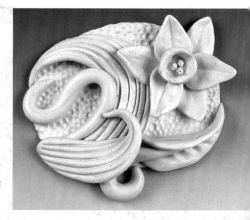

There are several ways you can make polymer look like it is metal. You can obviously use the metal-colored polymer clays (several different gold, silver, bronze and copper colors are available), which will create a somewhat metallic look. You can dust polymer with a solid covering of metallic mica powder (both shiny and antique versions of all the metals are available). You can cover clay with metal leaf or metal foil (for the difference between the two, check the back of the book). You can paint baked clay with metallic paints (acrylics, oils and other specialty paints in a variety of metal finishes are available). And there are metal coatings to paint actual metals onto the surface of your clay. I've used all of them, and each has a different look, and different circumstances in which it looks best. My preference is metal leafs and metal coatings. Metal coatings are available in more metals and are more versatile and have the added advantage of being able to be oxidized in order to realistically age them.

So, let's go there! To metal coatings, hoorah! I'm using 'Swellegant" coatings, because they rock. I wanted to make this pendant look like old brass, so I used the Brass Swellegant. Pretty obvious choice, huh?

Start by using a brush to dab/brush on a layer of the metal. It paints on like an acrylic paint. The first coat will be uneven, with thin spots. Don't worry about it. Although, you'll probably find it's better to dab the paint on a bit more than stroke it on to get better coverage.

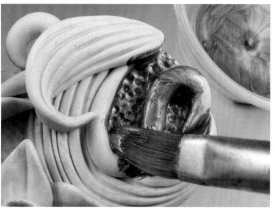
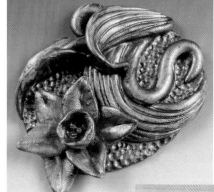

Let the first coating dry. Coat the back. Let that dry. Add a second coating to front and then back, and let that dry. If there are any thin spots, add another coat. It's helpful to put the piece in a warm spot to help it dry faster.

I pop mine back in the oven. Don't worry, you won't hurt the coating.

Ok, ready for the fun part? To age and oxidize the metal, we need to add a patina, which will react with the metal to change it. This only works well if the metal coating is still moist, so paint the front of the piece once more with the metal coating, and WHILE it is still wet, coat it thoroughly with Darkening Patina. The reaction of the Darkening is pretty quick so you'll see it start to turn a warm brown-black, especially in the detail areas.

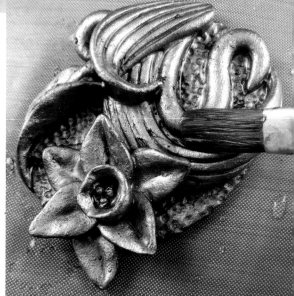

You now can add a liberal dose of Tiffany Green and/or Green Gold Verdigris Patinas. Use plenty! This will make the brass become that classic green verdris color – like the Statue of Liberty! You'll have to be patient, it takes 5 or 10 minutes for the green to start to bloom (and when it does, it first looks like an icky green gray, but be patient!). You can spritz the piece with a mist of water while you're waiting to keep it moist, or add a bit more patina – keeping it wet is crucial for a good bloom! I don't know why, it's a science thing.

Once the patina-fication process starts it will just keep on going. You can minimize how much oxidation you'll get by rinsing the piece gently with water and patting it dry to wash off the excess patinas, but those already permeating the metals will still keep working. I suggest you let the patina do its thing and then come back to the next step the following day if you can. Or you can put it all back in the oven for about 15-20 minutes to dry it out, which helps halt the reactions.

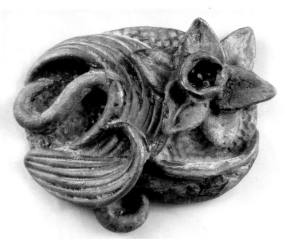

So at this stage it should look old and grungy. Probably much more icky than you really want it to. That's exactly what is supposed to happen.

The really cool thing about using a metal coating and patina combination like this is that the result is realistic and unpredictable. The materials are doing much of the designing for you, it's up to you to decide what you like and what you want to minimize. Having to fake the look of patina takes skill and practice (and of course that can be fun!), but having real patina do its own real thing, just takes a little time.

Ok, so now to take the grunge and make it delightfully aged.

Get a bit more of the same metal coating on a flat brush, then brush it back and forth on a bit of paper (like an index card). Brushing it will expose it to the air, which will evaporate the moisture and thicken the paint. When the paint is thick, but not yet crumbly, swipe it over the highlights of the piece. This is a dry-brush technique (for obvious reasons – the brush uses paint that is much more dry than usual). This will put a coating of metal over the top of all the high spots and at the same time cover over some of the grungy patina.

What do you think? It looks a lot better now, huh?

And of course, the wonderful thing about working with 'Swellegant' metal coatings and patinas is that you can coat and recoat as often as you want to get exactly the right look.

I love how these can add a whole new option of creativity to polymer clay. It definitely is one of those materials that is worth experimenting with!

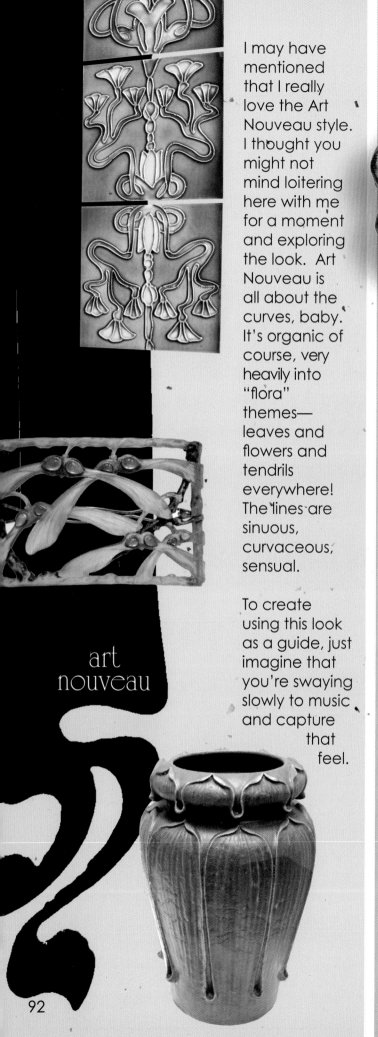

I may have mentioned that I really love the Art Nouveau style. I thought you might not mind loitering here with me for a moment and exploring the look. Art Nouveau is all about the curves, baby. It's organic of course, very heavily into "flora" themes— leaves and flowers and tendrils everywhere! The lines are sinuous, curvaceous, sensual.

art nouveau

To create using this look as a guide, just imagine that you're swaying slowly to music and capture that feel.

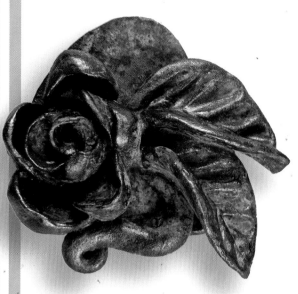

One of the most interesting things about working with the metal coatings is that everything becomes all about form, line, and composition. Since color is taken out of the picture, for the most part, the lines of the piece have to stand on their own merit.

Of course, sometimes you just get lucky, when covering over a piece, to discover that it looks even better in metal than it did before.

This piece started out as a stained glass project that got scorched during baking, making it a perfect candidate for covering with metal. I think the metal coating looks even better than I expected. Hooray for happy accidents!

Art Nouveau-style composition is energetic, busy, **almost** cluttered (but in a good way). As a change of pace look at these pieces – they're clean, contemporary, and simple (but in a good way).

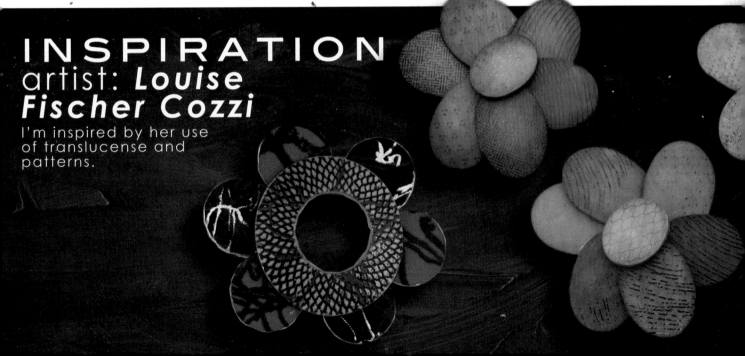

# INSPIRATION
## artist: *Louise Fischer Cozzi*

I'm inspired by her use of translucense and patterns.

# random flora TEXTURES

Texture. It's everywhere. Have you noticed? Obviously, the world of flora abounds with textures. We could spend a lot of time exploring bark and roots and seeds and fungi and lichen and and and....

Here are some pictures to get you thinking, and get you looking at the flora around you for inspiration. Beads are an especially good vehicle for textural treatments ('vehicle' in the art sense, although if you can figure how to use one for transportation, will you let me know?).

So, keep your sketchbook nearby on your next wander and just look at the textures around you. What can you do with them?

Try running some clay through your clay conditioning machine to make it thin. Hold your hand underneath the rollers to catch it as it comes through, so that it pleats.

Spikes are fun! Roll out a tiny tear drop, and smash the fat end onto a bead. Pokey!

Photo by Ricki Cole

94

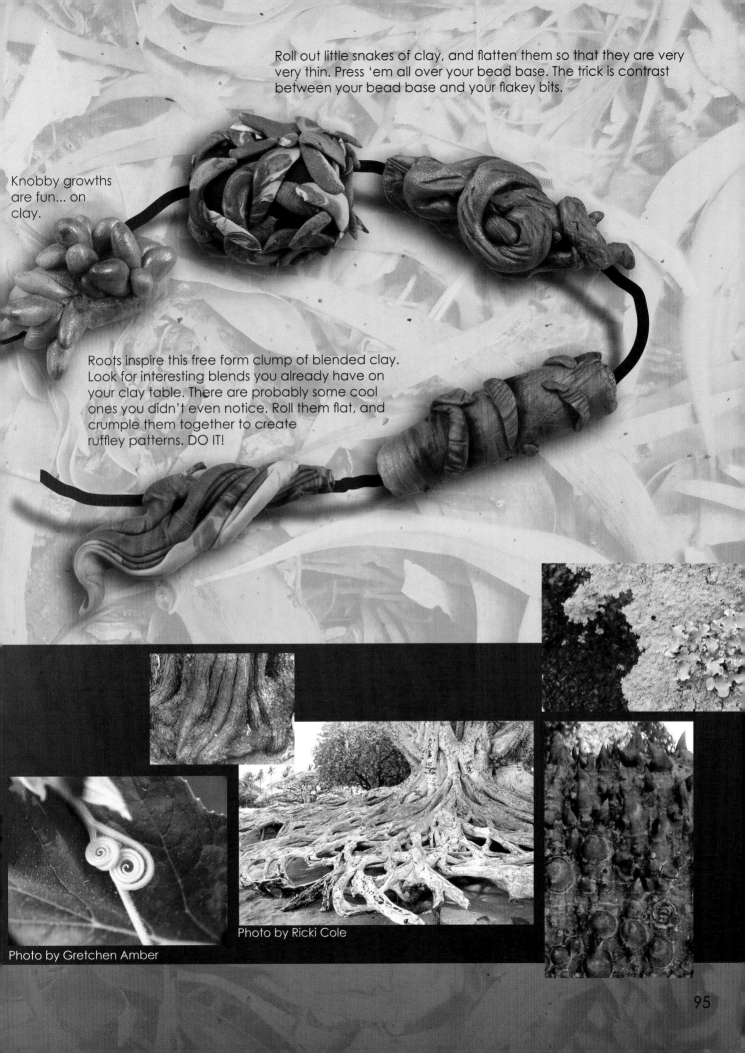

Roll out little snakes of clay, and flatten them so that they are very very thin. Press 'em all over your bead base. The trick is contrast between your bead base and your flakey bits.

Knobby growths are fun... on clay.

Roots inspire this free form clump of blended clay. Look for interesting blends you already have on your clay table. There are probably some cool ones you didn't even notice. Roll them flat, and crumple them together to create ruffley patterns. DO IT!

Photo by Ricki Cole

Photo by Gretchen Amber

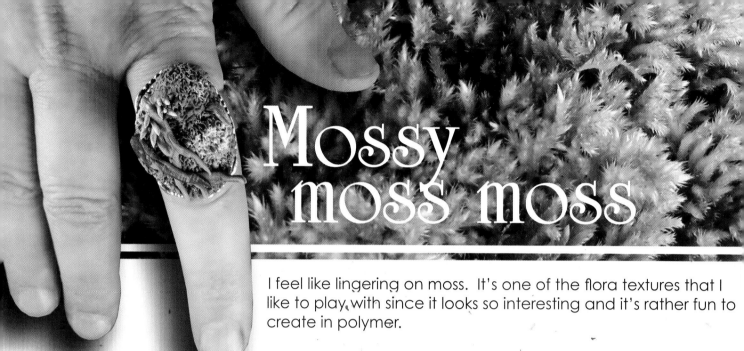

# Mossy
# moss moss

I feel like lingering on moss. It's one of the flora textures that I like to play with since it looks so interesting and it's rather fun to create in polymer.

I'm going to make a little mossy ring. You can too, or make a pendant or decorate the top of a box or whatever. Start by using PolyBonder™ to adhere a bit of green clay to a ring base (or pendant base if that's what you're doing). As usual, if the finding is a bezel-style, that works best (look in the back o' the book for some resources for rings and other fun stuff).

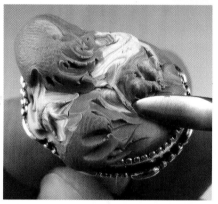

Roll up some balls of green clay (a few different blends will look nifty) and press them onto the base clay.

Use a tool to blend the balls together a little to mix the colors and flatten the edges a little so that they look like rough mounds, not flattened balls.

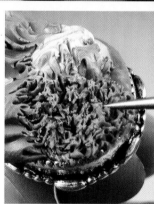

Now use the tip of your needletool to poke and scratch and flick – ALL over! The key to making the moss look mossy is lots and lots and lots of poking and flicking so that the whole surface becomes altered, otherwise it just looks like your clay has chicken pox.

Once your moss is all mossy, add other features to make the piece look more realistic – like tiny twigs. Make a twig by pressing together several itsy snakes of brown clay. A center stem with a few twigs pressed on will look quite realistic.

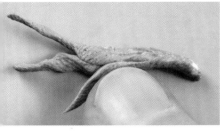

Press the twig in the moss, then use the needle tool to fluff the moss onto the side of the twig in a few places. This makes the twig look like it is naturally in the environment, not just something laid on top. If you want even more realism, press in a few tiny grey clay pebbles, or a few teensy sprigs of grass.

Remember the clothespin trick when you bake! And it's especially important to bake the clay hot enough when doing rings so they'll be properly fused. Rings get a lot of bumping

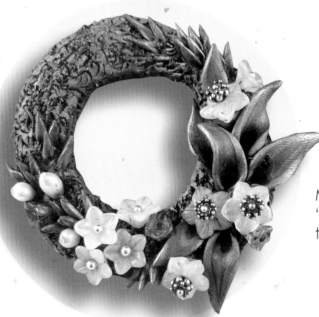

Mossy details are a great way of filling up "blank" space that is needed for the design to flow properly. Plus it just looks great.

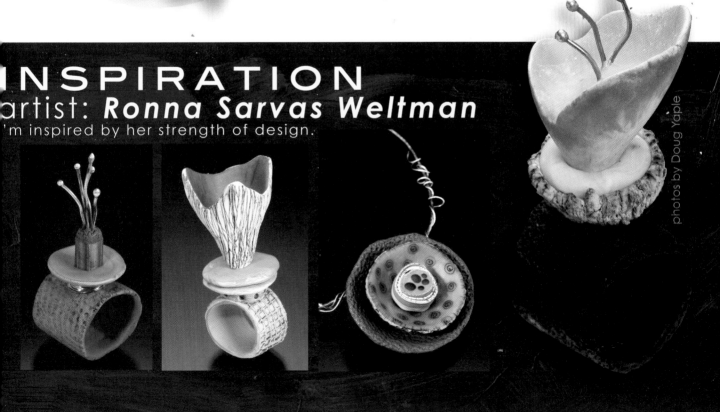

# Trees

ahhhhhhh, trees.
lovely, aren't they?

photo by Ricki Cole

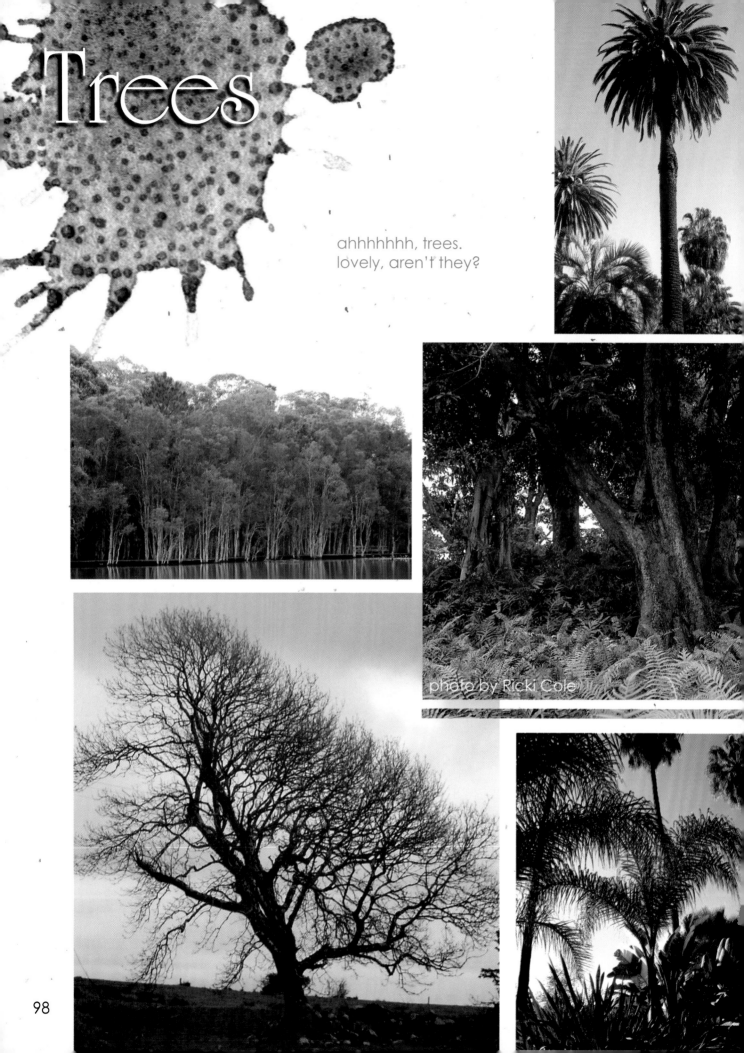

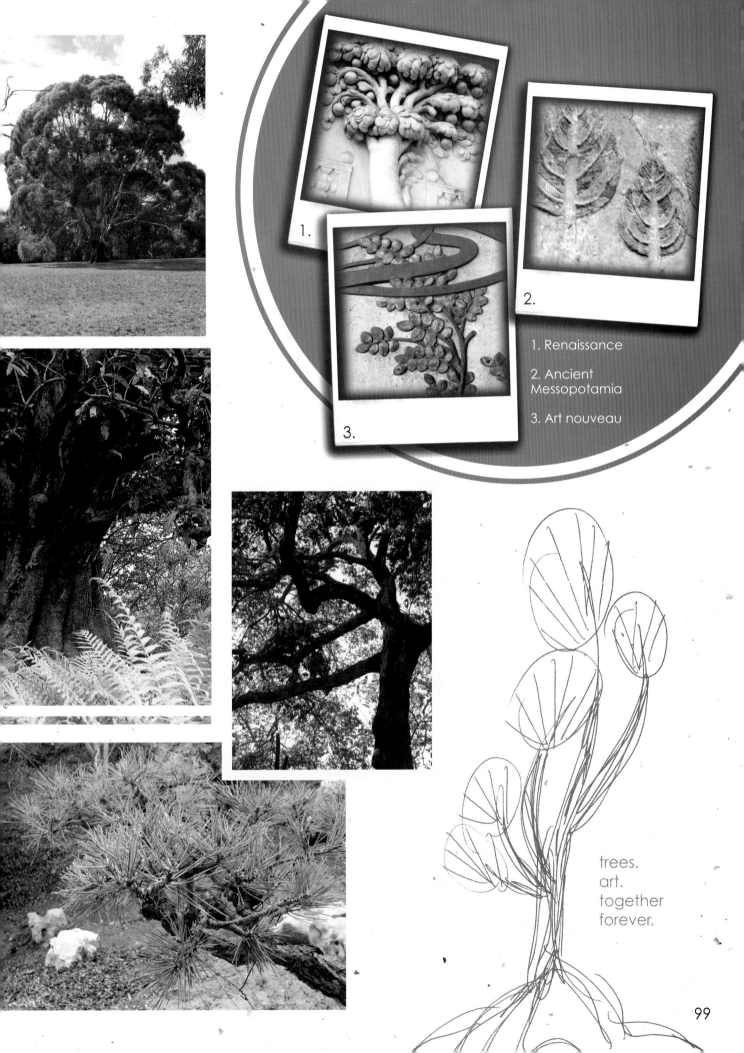

1. Renaissance

2. Ancient Messopotamia

3. Art nouveau

trees.
art.
together
forever.

Just a few tree ideas to give you some possible avenues of arboreal artistic exploration.

100

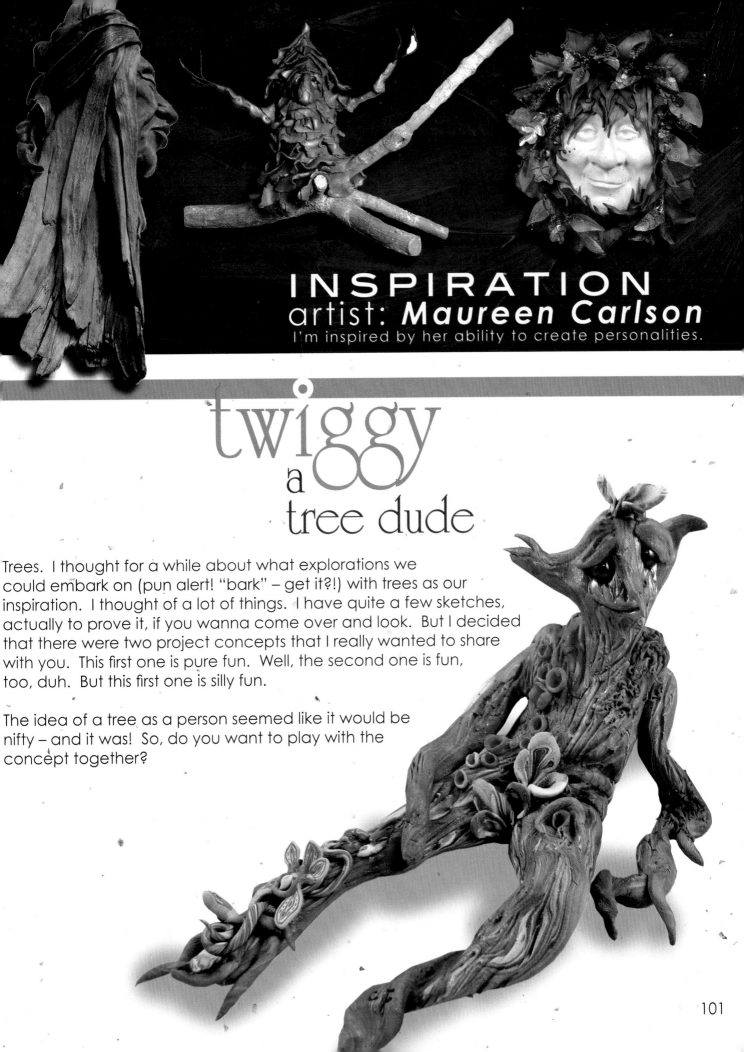

# INSPIRATION
## artist: **Maureen Carlson**
I'm inspired by her ability to create personalities.

# twiggy
## a
## tree dude

Trees. I thought for a while about what explorations we could embark on (pun alert! "bark" – get it?!) with trees as our inspiration. I thought of a lot of things. I have quite a few sketches, actually to prove it, if you wanna come over and look. But I decided that there were two project concepts that I really wanted to share with you. This first one is pure fun. Well, the second one is fun, too, duh. But this first one is silly fun.

The idea of a tree as a person seemed like it would be nifty – and it was! So, do you want to play with the concept together?

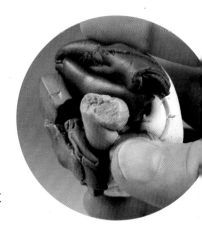

Let's start by making a blend of clay that looks like a weathered tree. That's easy, just use the "gather up all the clay bits on the table and see what that looks like" method. It's a good method. Of course, do make sure that the clays you gather are all in the "wood-friendly" color scheme.

You'll need a wad of clay about as big as an avocado pit, or a small boiled egg. Roll the wad flat and then run it through the clay-conditioning machine set to the widest setting. Rip and stack and mush it a flat again. Repeat that until you have a nice clump of clay made up of lots of thin little layers.

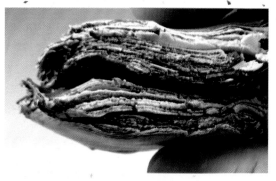

Slice the clump open with a blade right down the center (to expose the layers), and then flip the halves so that the cut side faces out. Press it back together. Roll the clump into a thick log, fold that in half several times until the log of clay looks like... well... a log!

Squeeze it to make the log look like a tree trunk with some bends to it.

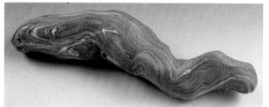

Look at it. Which end seems like it should be the head? Which end the legs? Use a cutting blade to slice the 'leg' end right through the middle. Squeeze each half into leggy things. Ok, before we go any farther, I want you to start thinking like a tree. How would your legs be if you were a tree? Like branches? Roots? Something in-between? Good, now squeeze the leg parts into something branchy-rooty.

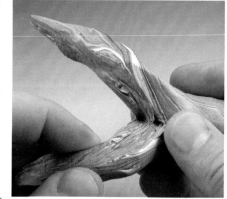

For the other end, the head is easily defined by squeezing the clay to make a neck, which will naturally separate the head lump from the body wad.

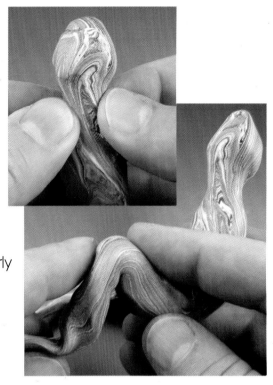

Twiggy dudes look good sitting down in a slouchy kind of way. Just vegetating (Get it?! Another pun alert – ok, I promise that's the last one... probably.) So, bend him at what you figure is the waist and adjust his legs to bend at knees and ankles. Or just let the root-ish legs curl and reach and do root-y things. (I made one of each kind of leg, because I liked both styles).

As you work on him (or her), you may want to lean him up against something (like a glass) to keep him slouching properly and not slumping. Slouching = good, slumping = bad.

I added ears next. No reason, I just felt like it. Pull some clay out from the head on each side, where you've determined the ears ought to go.

I thought some creases where one of the legs bend would mimic the way tree branches sometime create creases at their joints. Use a tool to press wide, deep lines into the clay, then push the clay to make the lines bunch up. This makes it look believable.

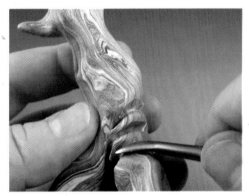

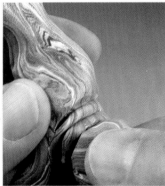

Arms are separate clay, pulled and pinched into shape (instead of rolled, which will blur the lines of the wood and make them look less woodi-ish).

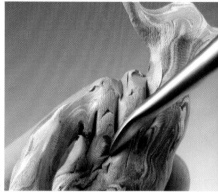

For one of the arms, I rolled out a couple thin snakes of clay, flattened them with my fingers, and wrapped them around the top of the arm piece (like woody shoulder pads!), then pressed this part onto the body. I used a tool to blend the arm onto the body.

As you position the arms, pose him so that he's both human-ish and tree-like. You can do that.

Let's give him a face. I poked a couple holes into the head where I thought the eyes should go. Press a small snake of clay onto the bottom of the face to make a lower lip, and use a tool to blend the bottom part of that lip into the clay. Don't blend in the top part of the lip. It's ok to leave some texture streaks in all these blending parts – it'll look delightfully tree-like!

Add another snake for a top lip, and blend in only the top part.

Press a tool into the corner of the mouth to pull the edges up, if you want your twiggy dude to be happier.

# INSPIRATION artists

**Dawn Schiller**

**Lisa Pavelka**

**Un-Roen Manarata**

Wire up a couple round, dark beads for eyes (refresher course in back o' the book, for the wiring bit). Press the eye beads into the eye holes. Press the beads in deeply to give him that furtive forest-dweller look. Add little flattened bits of clay for eyelids, if you want to. The way you position the eyelids will determine his personality, so take some time to experiment with how they could look. Press them to attach, once you like it.

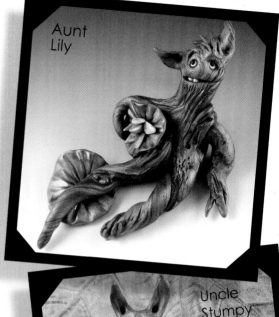
Aunt Lily

Add a nose by pressing on an interesting shape of clay in the middle of that loggy face!

Ok, so now we can play with some of the things we've already done to embellish the dude and make him look more like a living log. How about a knothole? He's got to have one of those, right? Just roll out a thin snake of tree-colored clay and flatten it. Roll it up like a sloppy cinnamon bun. Press it on and blend it in. Blend so that it looks like a part of the tree.

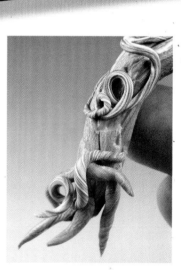
Uncle Stumpy

While you've got you're tool out, you can add other blending lines anywhere on him that you think look good and barky.

Roll out small snakes of clay for twigs and press them on feet for toes and hands for fingers. Add the twigs to all the limbs, or just a few – whatever you like!

A green snake of clay can meander up an arm, twisting and curling to form a vine or tendrils.

You know that weird cup-like fungi that grows on trees in the dark forests? And sometimes it's rather brightly colored – so let's add a few of these to his body. I'd wear them if I were a twig person. Pick a color (they can be brightly colored) and roll out some small balls of clay. With a ball-tipped tool, press the ball of clay around the tool tip to shape it into a cup.

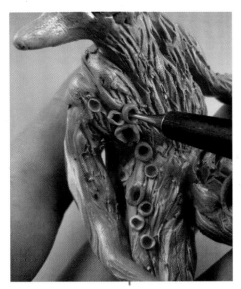

Press the clay onto the twiggy dude by pushing it on while it's still on the tool, then twisting the tool to pull it away from the cup.

Add a few leaves if you want. I used a cluster to hide his knotty bits (oooh, another pun... and after I said there wouldn't be any more! For shame!)

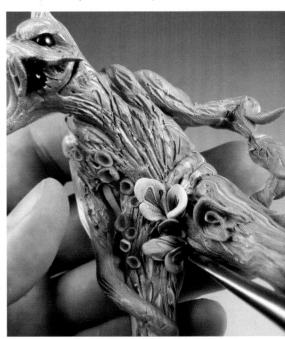

A nice, stringy sort of moss is another nice foresty accent, and just what the fashionable tree people are wearing this season. Roll out a long, thin snake of green clay, then gently clump it up. Press the clump in a likely spot and use your tool to do the mossy trick – poke and scratch and flick!

Add anything else that you think would enhance him – perhaps a small orchid nestled into the vine would be nice. More leaves as a hairdo? See what happens when you just play.

Once you've added all the woodsy details that you think he needs, bake him! But do remember to use toilet paper or something else to prop him up in the oven. For example, if you leaned him up against a jar or bottle while creating, you can still lean him against a glass jar/bottle in the oven (a little pad of tp will make sure the contact with the glass won't leave a shiny spot), Otherwise, just use paper to hold all the bits up!

You will probably want to make more, I did! They really are fun, aren't they?

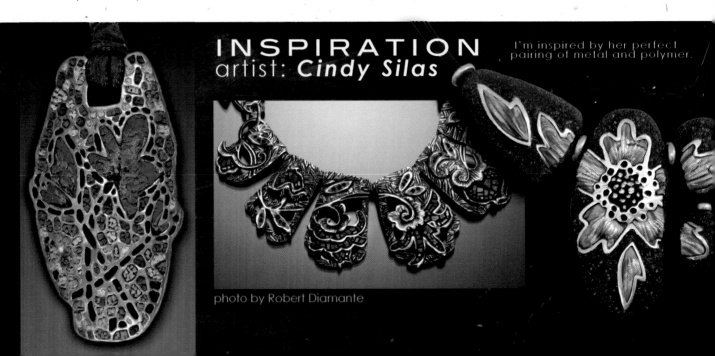

INSPIRATION
artist: *Cindy Silas*

I'm inspired by her perfect pairing of metal and polymer.

photo by Robert Diamante

Well, somehow we got to the end of the book, or at least the end of the chatting and exploring and projects. How did that happen? Seems like time just flew by, doesn't it?

I thought that ending the projects with a tree would be good, and in fact necessary since we haven't spent a lot of time on trees. But then I thought that maybe some new technique to end on an exciting note would be the way to go. There's nothing more fun than bringing something to an end by introducing something new. And then I thought "I have all these little bits and pieces lying around, maybe it would be good to finish with the concept of gathering up unfinished business and turning it into a finished piece". And then I thought that was entirely too much thinking for one day, so I took a nap.

So of course the obvious solution is to finish with a project that is all of those. You saw that coming, didn't you. Mosaics. This technique fits all those requirements nicely. It's a technique we haven't done yet, so that makes it new, it uses bits and pieces lying around, and we can make a tree out of it.

# MOSAICS

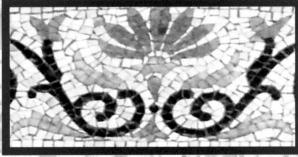

The idea behind mosaics is simply to press bits into a grabby substance. That's it. You can use polymer clay as the grabby substance (regular polymer clay or liquid clay or a mixture of the two). You can use epoxy clay, or you can use concrete. I just got to play with MATRIX, a new jewelry concrete product – it's perfect for this, I think you'll want to play with it too. I like it better than some of the other things we could use for mosaics because it can have sand, tiny pebbles, round shells and other things to give the concrete a wonderfully gritty look.

Matrix jewelry concrete is easy to use (follow the directions, duh). You just add liquid to the concrete mix to make a stiff mud. You can then fill a space (like a bezel or a frame) with the concrete, or go freeform! I created a tree-ish shape on paper (although working on plastic wrap or a teflon sheet works better.

Now just start pressing things into the concrete to make a mosaic! Some things like rocks, glass, gems, ceramic and metal will adhere beautifully to the concrete when it hardens. Other things, like plastic (and that includes polymer clay) may need a little dab of glue (like PolyBonder) to make sure they stay put. After the concrete dries (overnight is good), just tug on the bits – anything that is loose gets the glue treatment. It's that easy.

I had some extra polymer leaves lying around (baked of course). And I also had a sheet of brown clay that I had pressed the cactus texture mold into. Chopped up into various shaped bits (including branch-like pieces) and baked, those made great mosaicy tree bits! Vintage glass flower beads looked good in there too, don't you think? A few random beads and it's done!

What sorts of things do you have lying around that you can use?

Let it harden (usually overnight is best). Then you can mix up a little more concrete to add a hanging loop on the back if you want to. (Just press a blob of concrete on the back of the hardened piece, stick a heavyweight wire loop into it, and let it dry. Done)

## Go mosaic it up! It's groovy fun.

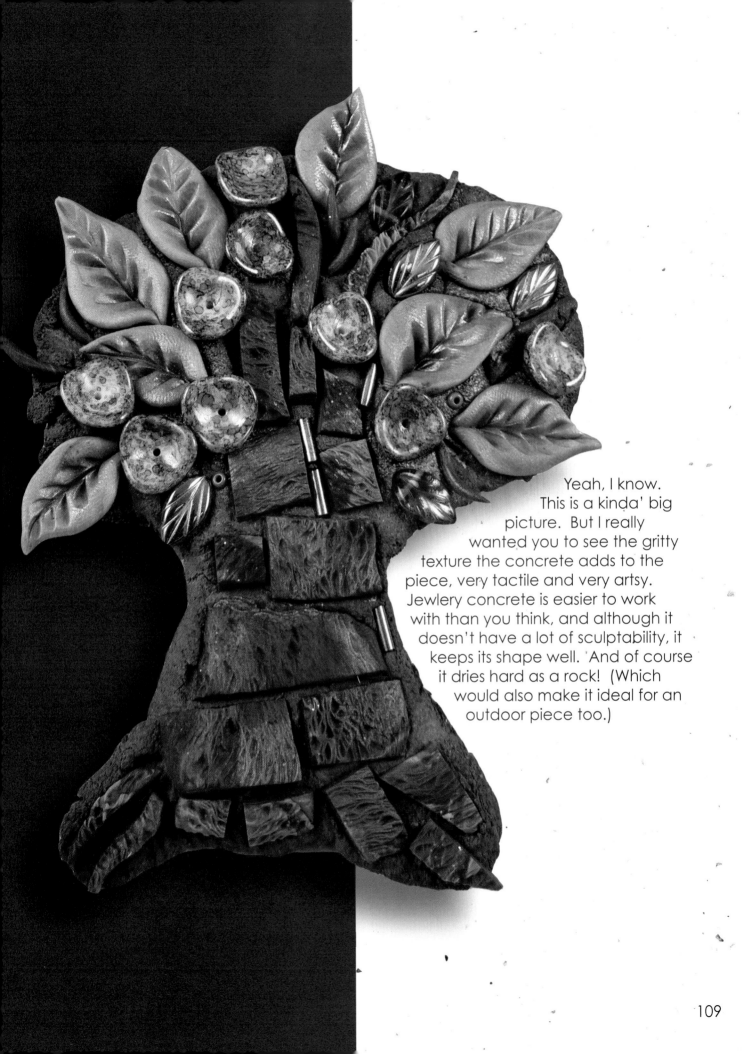

Yeah, I know.
This is a kinda' big
picture. But I really
wanted you to see the gritty
texture the concrete adds to the
piece, very tactile and very artsy.
Jewlery concrete is easier to work
with than you think, and although it
doesn't have a lot of sculptability, it
keeps its shape well. And of course
it dries hard as a rock! (Which
would also make it ideal for an
outdoor piece too.)

# THE END

Well, that's it.

Ta ta!

Go play with all this stuff and don't forget to show me what you make. We all learn from each other, and show and tell is always fun.

May the grass in your polymer path always be green, and properly conditioned.

Happy creating!

I figured some of you knew everything, some of you knew nothing and the rest of you were somewhere in between, so here's the basics, the tricks, the techniques and some other interesting stuff!

Let's start with an **overview of the polymer clay basics**. That's a logical place to start. I was going to start with a recipe for Amazing Chocolate Cake, in case any of you wanted to bake one for me... we'll see if there's room at the end for that.

Polymer clay is awesome. There are **several brands**, they're all awesome. Each brand has things it does best, and things it doesn't. For sculpting and simple caning (like we did in this book), I recommend Premo™ clay. It's my favorite! If you get into more detailed caning, you may prefer a stiffer clay like Kato™ or Fimo Classic™. Additionally, there is **UltraLight™** polymer clay, which is very light and fluffy and great for carving. And **liquid clay**, which we'll talk more about soon. You can buy polymer clay at your local craft stores and online.

Clay needs to be **conditioned** before using. This simply means warming up the clay so it becoms soft and flexible. Condition your clay by hand or with a roller, or with a clay-conditioning machine (that's a pasta machine, for anyone who doesn't speak ArtsyFartsy). Just take a manageable bit of clay and roll, twist, fold and bend it until it's soft. Or use a roller to flatten, fold and repeat until it's soft. Or flatten some clay by hand, then feed it through the rollers of a clay-conditioning machine (set to the widest or second-widest setting, folding and re-feeding until it's soft).

I like to **mix colors and condition at the same time** because different degrees of softness in clay colors make for some very interesting patterning. In fact, I like to make a **"Lookit Blend"** when I'm conditioning/mixing. I call it that because you have to *look at it* each time it goes through the machine, and at some point you'll say "*Lookit!* What a great color!" or something similar to that, anyway. To make this kind of blend, use several colors or scraps of color, run them through the machine once, then rip and stack them randomly and run through again. Now fold up the sheet of clay so that the interesting colors are right where you can see them and run it through again. *Look at it.* Choose the interesting bit again, fold and run through.

Repeat until that LOOKIT! moment comes.

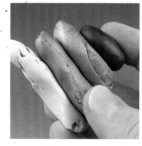 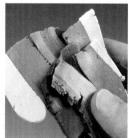   

Another way to mix clay so that you achieve a smoothly graduated blend from one color to another is called a **"Skinner Blend"** (named after Judith Blend who created it... oh wait, I mean Judith Skinner). It's a very useful blend, especially for those who really get into caning! I'm not the best at it, but here goes! Roll out two colors of clay. Cut them into squares of the same size. Cut them each in half, diagonally. Press the two halves together and trim top and bottom so that the diagonals are not exactly corner-to-corner any more. Fold this in half and feed it through the clay-conditioning machine, fold-side first. Continue to fold and roll, always folding exactly the same way and feeding the clay into the machine the same way. When the blend is a smooth graduation from one color to the other, you're done! You may have to practice a bit to get the hang of it (don't worry if it's not perfect, I won't tell anyone).

With this blend, you can do many things, one of the most handy of which is a **bullseye cane** - fold it long-ways so that you see all the blend (just narrower), and roll that through the machine, LONGways to make a long, thin ribbon. You can gradually make the clay-conditioning machine tighter and tighter to make the ribbon thinner and longer. Now roll it up!

When not playing with your clay, or if you're still working on a piece, but need to set the clay aside for hours, days or weeks, **take the clay off any porous surface** it's sitting on (like paper or wood) and place it on glass or on plastic wrap, or in a plastic food bag for storage. To be able to continue working on your not-finished project again later, hold it in your hands and let your body heat warm it, so it will be soft and flexible again. You can also wrap your canes in plastic wrap to keep them dust-free, and non-sticky. Warm them in your hands before slicing so you won't get any cracks in the slices.

Here's a random bit of info: One of my favorite shapes to use is a teardrop, because it seems like so many things start out with this shape. "If in doubt, make a teardrop," I always say. **To make a perfect teardrop**, roll clay into a ball, then hold your hands in a "V" position, palms together and let the clay ball drop into the "V". Slide your hands back and forth, still in a "V" position, so that you squeeze the ball of clay only on one end with the "V" of your palms. Tah dah! Perfect teardrop.

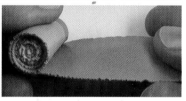

Caning. Some of you will LOVE making **canes,** and for others, meh.... If you're interested in continuing to learn about caning, I've got a free LEAF CANE project that you can download! (Click on the "downloadable projects" button on my website: www.ChristiFriesen.com) For more information on caning, the best way is to just google "polymer clay, canes, caning" – there are sooo many sites to visit, tutorials to enjoy and images to drool over.

**Antique-ing** adds a nice depth to a finished piece. It mellows bright colors and adds a look of age. It's easy to do - just brush your finished piece with brown acrylic paint (I use several different browns depending on what color clay it's going on). Then wipe all the surface paint off, using damp sponges. Work in small areas at a time.

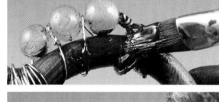

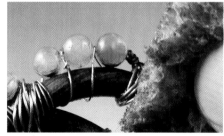

Ok, so now the main tip you'll need. Are you paying attention? BAKING! **Baking is the most important part of creating with polymer clay.** If your piece is perfect and it's under-baked, it will break. Nobody will realize how awesome you are if your piece is a broken mess. If it's over-baked, it will scorch or even melt in an awful, Chernobyl kind of way. That's no good.

**So, here's everything you need to know about perfect baking.** 1. PREHEAT your oven for long enough for it to reach proper temperature *before* you put your clay in. 2. Use an oven THERMOMETER so you know accurately what temperature it is *inside* the oven. The oven knobs are liars, don't trust them. 3. BIGGER IS BETTER when it comes to ovens (and perhaps to other things as well), so use the largest oven you can. Little toaster ovens tend to scorch everything because their heating elements are too close to the clay, so go big!

113

Once you're set up, your oven is preheated with thermometer in place, now you can bake your clay on a pan, or on a ceramic tile. First put it on a piece of clean, stiff **paper** so the clay will not get shiny where it touches the smooth surface of the pan/tile. Don't worry, the paper won't burst into flames. It may darken after several bakings, though, so replace it as needed.

Use adequate **ventilation** when baking. If you use your home oven, you'll need to clean it before using it to bake food (ugh) OR you can bake the clay **inside** something to trap the residual polymer so it doesn't get inside your food oven in the first place. I suggest an **oven-roasting bag**, or a lidded foil turkey pan.

Follow the time/temperature suggestions on the clay you're using. For Premo™ you'll bake at 275F (130C) for 20-30 minutes per quarter inch at the thickest part. So, for most sculptural pieces, that means **45 minutes to an hour** in the oven.

**Clay fuses in the heat, but hardens as it cools,** so don't expect your clay to turn rock-hard in the oven (at most it will feel like a pencil eraser). Also, properly baked clay is strong, but flexible in the thin spots, so if your clay flower petals bend after baking, you've baked correctly! If they snap off, cry a bit and then go back and fix your baking situation and bake longer and/or hotter.

You can re-bake polymer multiple times! Liquid clay will let you add fresh clay to baked clay. Then the final baking should be for the full time.

Ok, now let's talk **TOOLS!** Any metal, wood or plastic tools are fine to use with polymer, but stainless steel tools work really well – they push the clay smoothly. Everyone has their favorite tools.

Most polymer artists become tool junkies... well, actually pretty much all artists do. Tools are cool. You don't need a lot of tools to be a good polymer artist, but it doesn't hurt. Here are the **tools I think are the most helpful**, in case you want to start accumulating them.

Sculpey™ ball-tipped tool
Speedball™ lino cutting tool
pliers – chainnose
pliers - roundnose
wire cutters
hand-held drill
craft knife
cutting blade
needlenose tweezers
needle tool

"Can't Live Without It" tool
"Wow It's Awesome" tool
"Gotta Have It" tool

Here's some assorted info about **mixed media** – in other words, all the stuff in this book that wasn't polymer clay!

**Wires** can be used inside clay to strengthen sculptural elements, be used as decoration, or be used to secure beads to clay. To **add beads to clay**, you can't just push them in and hope for the best. Well, you can... but, good luck with that. Clay is plastic, so the beads will just pop out eventually - they need to be anchored to stay secure. Wire or headpins work best for this. To **wire a bead**, first snip off about an inch or two of 28 gauge wire (use wire cutters, not your teeth, silly!). Slip on the bead. Pull the wires together so that the bead rests at the bottom. Use pliers to hold the wires together, and fingers to twirl the bead so that the wires twist up to the base of the bead.

Trim off the excess wire and use pliers to bend a hook in the end of the wire. This completed wire should be between an eighth of an inch and a quarter inch long. To add the bead to clay, press the hook in first (duh) and push the bead until it embeds just a bit into the clay.

**Use a wire headpin** the same way. Slip on the bead, trim the wire, bend a hook in the end, push the headpin/ beads into the clay.

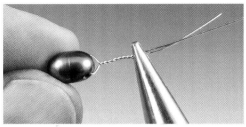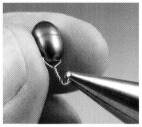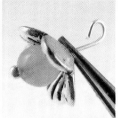

Sometimes you do need glue! Here's a simple guide to **what glue when**:
• for connecting clay to clay: liquid clay (like **Translucent Liquid Sculpey™**). This works on unbaked or baked clay.
• for adding craft media to clay (like glitter or fiber): use a heat-activated craft glue like **Sculpey Bake&Bond™** if you want to add it during the sculpting process and bake it in place, or use a craft glue like **WeldBond™** if you want to add craft media after the clay is already baked.
• for adding non-porous materials to clay (like glass or metal) during sculpting, use Lisa Pavelka's **PolyBonder™** (which keeps its adhesion through the baking process) OR use any cyranoacrylate glue (super glue) after baking, like **LocTite**, or any two-part epoxy.

The **embellishments** that we used in the book are only some of what can be used with polymer clay. I hope you'll keep experimenting! I really enjoy using embellishments during the sculpting process and then baking them in. Anything that can go into the oven at 275F (130C) for an hour is good to use! So that means all glass, crystal and stone beads and rhinestones are great to use! So is anything made of ceramic or metal (including wire, sheet metal, foils and metal leaf). Wire, glue or otherwise secure any embellishments you use into the clay.

Some **surface treatments** like chalk, mica powder, embossing powder, glitter and metal leaf are just brushed or pressed onto clay and then baked right on. Others like pencils, paints and inks are added to baked clay.

To **seal your finished clay and to protect the surface treatments,** you can use a clear glaze, but it MUST be compatible with polymer! Not all glazes are! Some excellent choices are PYM II™ spray-pump Protective Sealer, Sculpey™ Satin Glaze, and Swellegant™ Clear Sealant.

And speaking of surface treatments, if you liked the look that the **Swellegant™ metal coatings and patinas** created, I've got more information on using them on my website. Check it out: **www.ChristiFriesen.com.**

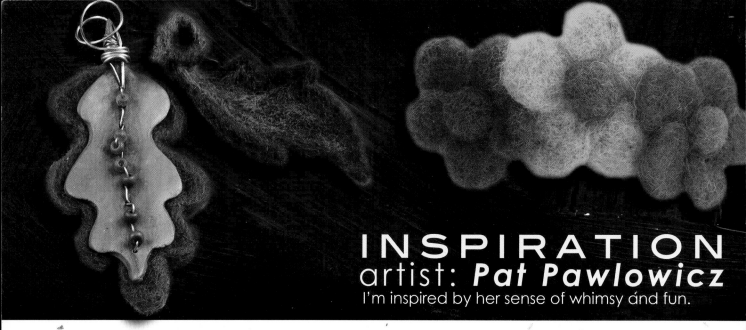

**Fibers** like wool, cotton and silk can be baked into your clay. **Hand-felted** elements combine especially well with polymer.

To **string a bead onto thick ribbon**, here's a clever little trick. Bend a 4-6 inch piece of thin wire (28 gauge is good) in half. Push the bent end through the bead hole. Open up the wires a little and slip the ribbon between them. Pull the wire and the ribbon through the hole. Tah dah!

Ok, one last trick! **Making a mold.** This is a great trick, and one that will really add to your creative options. Of all the mold-making materials, the best by far to use with polymer clay is silicon. You can easily make a mold using a 2-part silicon molding material. And silicon molds are wonderful to use – polymer clay does not stick to them, so no sprays or powders to release the mold are needed. You can also bake the clay right in the mold, then pop it out if you want to be sure of having no distortions in your molded piece.

First *prep the item* to be molded. You can mold anything - natural materials, metal filigree, polymer creations.... Just make sure the piece to be molded is pressed against a flat surface so the silicon won't sneak underneath. You can use a flat slab of unbaked polymer to press the item onto. Fill in any open holes. Now, to make the mold, use equal parts of the 2-part silicon mold material. Mix thoroughly, but *quickly* – this stuff starts setting up sometimes within one or two minutes of mixing! Press the mold material over the surface to be molded. Let it sit undisturbed until it hardens – from 5 to 30 minutes (depending on the freshness of the molding material). You can tell when it's done if a fingernail pressed into the silicon doesn't leave a mark. (If the mold material is old, it may take a lot longer to set up – just leave it overnight and cross your fingers!) Once it's hard, pop it off and use it.

 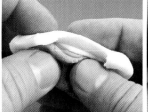  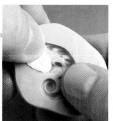

You're on your own for now. Happy creating!!